EUROPEAN FIREARMS

DISCARD

VICTORIA AND ALBERT MUSEUM

EUROPEAN
FIREARMS

BY J. F. HAYWARD

LONDON
HER MAJESTY'S STATIONERY OFFICE
1969

SBN 11 290052 6

FOREWORD

THE INTENTION of this work is to provide a guide to the Museum Collection of firearms, not to offer a general history of the subject. The numerous historical and technical problems which are likely to be encountered by the student of the subject are therefore only discussed in so far as they arise in connection with objects in the Museum collection. This collection, having come to the Museum almost entirely through gift or bequest, has not been assembled according to any consistent policy of acquisition and there are numerous gaps in relation both to technical development and decorative design. Recent acquisitions have all been purchased out of a fund bequeathed by Major V. A. Farquharson, F.S.A. who also gave his collection to the Museum. The name of this benefactor will be encountered frequently in the catalogue of selected pieces which forms the main body of this guide, and even more so in the Gallery where the collection is exhibited. The examples described and illustrated in the catalogue have been selected from the main collection on grounds, firstly, of artistic merit and, secondly, of technical or historical interest. The fact that any particular type of mechanism or ornament is not represented in the illustrations does not necessarily imply that there is no example in the Museum.

This handbook was first published in 1955; in this new edition the text has been completely revised and a large number of illustrations added. Its author was formerly Deputy Keeper of the Department of Woodwork.

JOHN POPE-HENNESSY
Director

EUROPEAN FIREARMS

THE GUNMAKING INDUSTRY

THE HISTORY of firearms has in recent years been the subject of a great volume of research, particularly relating to technical development. Though the main course of their evolution is now established, there are still gaps in our knowledge, mostly relating to the date of introduction of the various lock mechanisms. The Museum collection of firearms has been assembled to illustrate the application of ornament, and the short introduction which follows is primarily concerned with changing fashions in decorations, though an account of the various mechanisms is given in an Appendix.

A firearm is a complex piece of mechanism in the production of which workmen of several different crafts must combine. The manufacture of barrel, lock, stock and mounts each requires different equipment and different types of skill and throughout the centuries it has only been the most prosperous gunmakers who have been able to assemble all the workmen required for these various processes under one roof. In the sixteenth and seventeenth centuries not only would it be exceptional for a gunmaker to carry out all the processes of manufacture in his own workshop, but the craftsmen who made firearms often belonged to different guilds, the barrel-smith to the Blacksmiths' Guild, the lockmaker to the Locksmiths' Guild, the stock-maker to the Joiners' Guild and the maker of silver mounts to the Goldsmiths' Guild. The situation varied very much from town to town and country to country, but even in Augsburg and Nürnberg, where gunmaking developed on a large scale as early as the middle of the sixteenth century, the gunmakers did not form their own guild until the seventeenth century. The same is true of Munich and Vienna. In London the Gunmakers' Company was first established in 1637, the gunmakers having previously belonged to the Armourers' or Blacksmiths' Company.

The division of labour between different workshops was particularly marked in Germany in the sixteenth and seventeenth centuries, and in Northern Italy in the seventeenth century. In England it has persisted into modern times. The eventual result of this division was that the gunmaker whose signature appeared on the lock or barrel was no more than a gun finisher who assembled parts which he had purchased wholesale from specialist workshops. If one examines a typical German wheel-lock rifle of the seventeenth century, it is likely that the signatures of three or even four different craftsmen will be found on it, that of the barrel-smith on the breech of the barrel, that of the locksmith on the lock, that of the gunstocker engraved or stamped behind the tang of the barrel, and in the case of some finely-decorated arms, that of the artist who chiselled the ornament concealed within the decoration of the lock, barrel or mounts. Specialization within the workshops on the manufacture of locks or barrels was paralleled by the establishment of specialized industries in certain towns. Suhl in Germany, Eibar and Madrid in Spain, Gardone near Brescia in Italy specialized in the production of barrels. Wheel-locks were, during the sixteenth century, manufactured on a large scale for export in Augsburg and Nürnberg. When a

weapon of the highest quality was ordered from a provincial German gunsmith in the early seventeenth century, it is quite likely that he would have obtained the barrel from Suhl, a fine quality lock from Augsburg, and then have sent the iron parts to Munich for decoration and gilding by the celebrated school of iron-chisellers that worked for the Bavarian Court. In this case only the stock would have been made by a local craftsman.

Some of the centres of gunmaking, such as Brescia, Ripoll in Catalonia, Carlsbad in Bohemia and Doune in Scotland, had their own clearly-defined style of ornament and techniques of manufacture to which the local craftsmen remained constant for long periods. Other centres such as the German cities of Augsburg or Nürnberg were more cosmopolitan in character, and though they might have their own local conventions, they were capable of producing weapons in whatever style their patrons might require. No. 11 (Plate IV), a pistol made in Nürnberg in 1593, is for instance equipped with a lock with mainspring fixed independently in the stock, a type otherwise confined to the gunmakers of France and the territories on the northern borders of France. Another cause of confusion in recognizing the place of manufacture of a particular piece is the fact that gunsmiths, after serving as apprentices in a large centre such as Augsburg, Liège or Paris, might move to some smaller town in their own country or even emigrate abroad, where, however, they might continue to work in the manner they had learnt during their apprenticeship. Thus we find the Augsburg gunmakers, who were brought from Germany in the sixteenth century to make wheel-locks in Spain, producing firearms there which give little idea of their actual place of manufacture. The local tradition invariably reasserted itself in the long run and the arrival of such immigrants made no permanent impression upon the national school of gunmaking, where such existed. The large-scale emigration of French Huguenot gunmakers after the Revocation of the Edict of Nantes in 1685 led, for instance, to the presence of highly-skilled Parisian gunmakers in London and other European capitals, but did not result in the lasting adoption of Parisian standards of form and decoration. Some of the firearms made in London by the Parisian gunsmith Monlong were as fine as any made in Paris at the time, but to judge by a pistol in the Museum (M.554–1924) he seems eventually to have adopted the less exacting English standards, presumably owing to the lack of a sufficient number of wealthy patrons, or the difficulty of finding skilled workmen.

Another exception to local or national practice is found sometimes in the work of the Court gunmakers. In the sixteenth and seventeenth centuries European princes and wealthier noblemen maintained one or more gunmakers amongst the artists and craftsmen attached to their court. The Museum collections include a number of firearms made by court gunmakers (Nos. 18, 88, 89 and 90 in the catalogue). The large financial resources of some princes enabled them to maintain foreign craftsmen at their courts, sometimes practising a style which was quite exotic. The most spectacular of these court artists were the two brothers, Emanuel and Daniel Sadeler, who came from Antwerp to work at the courts of Duke Maximilian I of Bavaria in Munich and the Emperor Rudolf II in Prague respectively. In 1610 Daniel also came to Munich, where he continued to decorate arms until his death in 1632.

The mere fact that a firearm bears a town mark on the barrel, or the signature of a maker

on the lock does not tell the whole story of its origin, and before attributing it to a particular source it is necessary to consider the form, workmanship and ornament of the other parts which constitute it. The following principles can be regarded as generally valid.

With the exception of the earliest period of gunmaking, barrel making was quite a separate trade. Even if the name on the lock is repeated on the barrel, this probably means no more than that the lock-maker has finished the barrel. The gunmaker proper was usually the lock-maker who assembled barrel, stock and mounts, finished them and fitted them with a lock. Normally the ornamentation of the stock with carving or bone inlay and of the lock and mounts with engraving would have been carried out in the gunmaker's own workshop, but where an exceptionally richly ornamented piece was required, such as the air gun (No. 94, Plates XXXIII, XXXIX, XL), the assistance of professional goldsmiths or engravers was obtained. It was not till about the middle of the seventeenth century that it became usual for the gunmaker to sign his name in full. Earlier, we find a locksmith's stamp and a barrel-smith's stamp, and, in the case of German firearms, the initials of the stocker as well. In the second half of the seventeenth century and subsequently, we usually find the maker's name on the lock, sometimes repeated on the barrel. In the case of Brescian firearms, the lock and barrel were signed separately, but, as a general rule, from about 1700 one name only appears on a European firearm, the barrel-smith's mark being struck on the underside of the barrel where it is concealed by the stock. The main exception to this rule is encountered in the practice of the English barrel-smiths of stamping their barrels on the upper side. The English Gunmakers' Company, to which all barrels mounted up by the London gunmakers had to be submitted for proof, also applied their marks on the left-hand upper side of the breech.

The ornament on firearms has for the most part been drawn from printed pattern books. The main exceptions to this generalization are to be found in those local schools of gunmaking mentioned above which were able to draw on an indigenous style of ornament. As soon as it became the practice to apply elaborate ornament to a firearm, the gunmaker found it necessary to look beyond his own resources or those of his workshop in order to find patterns appropriate for decorating his productions.

Throughout the sixteenth century a constant supply of ornamental designs was issued by the engravers of Nürnberg and Augsburg, such as Peter Flötner, Virgil Solis and, later, Jost Amman. During the sixteenth century, these same cities of Augsburg and Nürnberg were also the largest manufacturing centres of firearms, and, as might be expected, the gunmakers made use of the designs produced by their fellow citizens. The majority of the engraved ornament on sixteenth and early seventeenth century firearms made in the area of Teutonic culture can be traced back to the œuvre of one or other of this small group of South German engravers. Towards the end of the sixteenth century, the designs of the French artist, Etienne Delaune, were much used, particularly by the Munich school, but this master spent some years in Germany and many of his designs were published there.

While the sixteenth-century engravers produced designs for cups, bowls and other examples of metal work, they did not publish designs specifically intended for application to the peculiar form and shape of a match-lock or wheel-lock firearm. It was, therefore,

necessary for the gunsmith to adapt the designs he found in the pattern-book to the shape of the lock, stock and other parts of the firearm. This work was doubtless as a rule carried out in the gunmaker's own workshop, but where a firearm of unusual splendour of ornament was required, the assistance of a professional was often called in. The Museum collection includes a series of sixty water-colour drawings of designs for the decoration of various parts of wheel-lock gun-stocks derived from the pattern books of Virgil Solis, Jost Amman and Paul Flindt, all artists of Nürnberg. Some of these (Nos. 12–15 and 25) are shown in Plates V and XI; they illustrate the intermediate stage that was necessary between the printed pattern-book and the decorated firearm.

As the demand for decorated firearms became greater, the engravers found it worth while to issue books of ornament specially designed so that the ornament could be copied directly by gunmakers without the necessity for adaptation. The earliest of these is a series of engravings of wheel-locks of French type, dating from the latter part of the sixteenth century and attributed to a follower of the French engraver, Androuet Ducerceau. Thereafter, a series of designs for firearms was produced by Parisian artists, covering practically every variation of fashion in ornament from the beginning of the seventeenth century up till the early nineteenth century. It is a peculiar fact that almost all the books of designs for gun ornament were the work of engravers working in Paris. Pirated editions appeared in Holland and Germany under other names, but the credit for all original work of this nature must go to France. The French designs of the second half of the seventeenth century evidently had a wide circulation outside the borders of France, and we find firearms made after the French pattern books by gunmakers in practically every European country. The most influential works were probably the two books issued by the two Simonins (Nos. 68, 69, Plate XXVIII), in 1685 and 1693 respectively, which appeared without acknowledgement later in two German editions and a Dutch edition. The Museum collection of engraved ornament in the Department of Prints and Drawings, includes all the important pattern books of firearms.

It was the practice in the gunmakers' workshops of the seventeenth and eighteenth centuries for the engraver to take a pull of the designs he executed on the metal parts of firearms. These were retained in the workshop, presumably as a record to prevent repetition of the same design. Such working pulls have survived in considerable numbers (Nos. 48 to 53, Plate XX) and are well represented in the Department of Prints and Drawings, where there are examples dating from the mid-seventeenth up to the nineteenth century. As the pull was taken directly from the engraved lock-plate or mount, the design and signature, if any, appears in reverse. It is an interesting fact that amongst a group of these pulls from lock-plates engraved apparently by the same hand, a number of different gunmaker's signatures may be found. This implies that, at any rate in the seventeenth century, one engraver decorated lock-plates and mounts for a number of the gunmakers working in his town. A similar conclusion may be drawn from the book of designs engraved by Jacquinet for Thuraine et le Hollandois *Arquebuziers Ordinaires de Sa Majesté* published in Paris in 1660 (No. 56, Plate XXII). It is evident that Jacquinet was a gun decorator by profession and in this work he shows not only locks engraved by him for

4

Thuraine et le Hollandois but also others executed for a number of other Parisian masters. By the end of the seventeenth century the leading Parisian gunmakers were probably capable of doing their own engraving, but we know from the correspondence between Nicodemus Tessin, architect to the Swedish court, and his agent in Paris in 1696 that, when firearms of particularly fine quality were required and no limits were placed on the price, the work was given to an outside specialist who was not employed by one gunmaker alone.

THE SIXTEENTH CENTURY

The Museum collection of firearms consists almost exclusively of pieces made for wealthy clients, and the plain military arms, which have always constituted the bulk of firearms production, are but slightly represented. The collection begins at about 1540, a comparatively advanced date in the evolution of firearms. At this date both match-lock and wheel-lock mechanisms were in use. By the middle of the sixteenth century the wheel-lock had already passed through half a century of development and had reached the form which it was substantially to retain for the next 150 years. It was formerly thought to have been a German invention and for the greater part of the sixteenth century the German cities of Nürnberg, Augsburg, Munich and Dresden were the largest manufacturers. Most of the surviving sixteenth-century wheel-lock firearms are of German manufacture or were produced within the German sphere of influence, that is, in Silesia, in the Dutch-speaking Netherlands or, towards the end of the century, in Denmark. The wheel-locks made in Amsterdam or in Copenhagen follow closely the German pattern, so much so that in the earlier days it is difficult to be certain whether a lock was made by an immigrant German craftsman or whether it was imported ready-made for mounting on a locally-made stock and barrel.

The earliest known reference to the wheel-lock is Italian and appears in Leonardo da Vinci's *Codice Atlantico*, which can probably be dated to the 1490's. Leonardo sketches two types of wheel-lock, one working by means of a spiral spring, while the other is the precursor of that generally used in the sixteenth century. Leonardo accompanies his sketches with notes explaining the functioning of the two types, so the wheel-lock may have been in use in Italy by the beginning of the sixteenth century. Whether the wheel-locks which Leonardo saw and described were of Italian origin or had been imported from Germany is not, of course, known but the former seems more likely. The next early reference to wheel-lock firearms dates from the year 1507 and relates to the purchase at an un-named place in Germany of a gun 'of the kind that is ignited with a stone' by the steward of Cardinal Ippolito d'Este, Archbishop of Zagreb, for his master's use in Italy. This gun can hardly have been anything other than a wheel-lock. A number of wheel-locks of very early type have been excavated in Hungary; all display the same feature of an external main-spring. Whether they were made in Hungary or imported remains uncertain.

The earliest surviving Italian wheel-locks are fitted to a number of combined wheel-lock pistols and cross-bows preserved in the Armoury of the Ducal Palace in Venice. These appear to date from the first quarter of the sixteenth century. They also have the

main-spring on the exterior of the plate, as do the Hungarian locks. The earliest German locks, on the other hand, have internal main-springs, which is a more advanced and presumably later system. It is characteristic of the early wheel-lock firearm that it was often combined with some other weapon, such as cross-bow, mace, sword or dagger, presumably because there was insufficient confidence in the efficacy of this new and complex mechanism.

Though there is a wheel-lock pistol combined with a crossbow in the Bavarian National Museum, Munich, which can be dated as early as 1521, those made for the Emperor Charles V, preserved in the Real Armeria at Madrid, constitute our most important evidence as to the beginning of the wheel-lock in Germany. As there are drawings of many of them in the *Inventario Illuminado* of the Armoury of Charles V and as some of them are dated and bear the mark of well-known Augsburg and Munich gunmakers, such as Bartolomäus Markwart and Peter Pech, respectively, they provide a reliable corpus of evidence.

The Charles V wheel-lock firearms consist of short carbines, evidently intended to be carried in holsters attached to the saddle, and pistols, both single and double barrelled. The carbines show already the *deutsche Kolbe* form, that is, the butts are straight sided, of angular section and are not intended to be set against the shoulder; the pistols have straight butts, continuing in the axis of the barrel. They bear dates between 1530 and 1547 and, though not the earliest wheel-locks in existence, they well illustrate the forms in use during the second quarter of the sixteenth century. While all have the same general type of lock, three different ways of attaching the cock spring are represented, a crescent-shaped spring placed around the lower half of the wheel with an arm extending across to the foot of the cock, a V-shaped spring placed on the inner side of the lock-plate and a V-shaped spring placed under the arm of the cock. An example of the first type is illustrated in Plate I (No. 1); of the second in Plate I (Nos. 2, 3) and of the third in Plate III (No. 7).

Amongst Charles V's firearms, the first type appears on a piece dated 1534, the second on one dated 1537, and the third on one dated 1531. Of the three types, it was the third that became the standard form. The first barely survived into the second half of the sixteenth century, the second dropped out towards the end of the sixteenth century, but is found in a modified form on some locks of the second half of the seventeenth century. Of the third type there were two forms. In one, the arms of the V spring were of equal length (No. 2, Plate I), in the other, the lower arm was considerably shorter than the upper (No. 3, Plate I). The form with arms of unequal length may have originated in Augsburg; it is certainly found on a considerable number of firearms bearing the Augsburg town mark. Whatever its origin, it was soon copied elsewhere.

Wheel-lock firearms dating from about the middle of the sixteenth century or earlier show certain common features. These include, first, the long drawn out shape of the lock-plate and, secondly, a cock with straight or almost straight arm, without the right angle which developed after the middle of the century. The form of the stocks also assists in identifying early wheel-lock firearms. In the case of the sixteenth-century arquebus, the sides of the butt are almost parallel (No. 6, Plate II); early in the seventeenth century

6

the stock widens out slightly towards the butt-plate and a wide flange is formed below the cheek-piece (No. 16, Plate VI). In the case of pistols, it is probable that the form of the butt was derived from the handle of the mace or war hammer. Some of the pistols of Charles V have butts in line with the barrel, like a mace handle. This form dates from about 1530–40, but as the century advanced, the angle between the axis of the barrel and the butt became less obtuse, until by the 1590's we find sharp angles, as on the Nürnberg pistol (No. 11, Plate IV) which is dated 1593. The fact that the angle between stock and barrel is slight is not however decisive proof of early date, for the straight butt returned to favour during the first half of the seventeenth century (No. 23, Plate X). Towards the end of the sixteenth century two types of pistol were ordered for the Bodyguard of the Elector of Saxony, the first with straight or nearly straight stocks, the second (e.g. M.64–1950) with butts set at an angle.

During the second half of the sixteenth century, two forms of lock-plate are found on German wheel-lock long arms. The earlier of these has a fairly straight lower profile, apart from a marked upward curve in front of the wheel (No. 16, Plate VI), the other has a lock-plate of approximately lozenge shape (No. 3, Plate I). Another feature of this second type, which possibly originated in Augsburg, is the presence of an indentation cut in the lower edge of the lock-plate below the cock-spring. On the early pieces, dating from the mid-sixteenth century this indentation is long, but it becomes gradually shorter until by the seventeenth century it is quite short (No. 3, Plate I). It is from this S. German lock form with indentation in the lower edge that the later Italian wheel-lock was developed. Certain further characteristics can be recognized: in the first type the lower jaw of the cock forms one piece with the arm of the cock, while the upper jaw is retained by the cock screw, in the second the position is reversed, the upper jaw forming one piece with the arm while the lower jaw is free. The modelling of the cock was also affected, thus with the first type the cock face is usually flat, with the second it is usually rounded. This distinction has a certain geographical validity: in Western Germany, Italy and France, the type with fixed upper jaw was with few exceptions normal. One exception may be seen in the French wheel-lock (No. 31, Plate XII). In Southern Germany the other construction was more usual.

Most of the pistols of Charles V are surprisingly plain, but even during the first half of the sixteenth century it became usual to decorate firearms made for rich patrons in a most elaborate manner. In Germany the stocks were decorated with inlay of engraved stag-horn and mother of pearl, or on the most luxurious examples with veneers of ivory and ebony: the metal parts were damascened with gold and silver. There are no early ex-amples of the richest ornament in the Museum, but the detached locks, M.493–1927 and No. 2 (Plate I) show the style in the last quarter of the sixteenth century while the pistol (No. 20, Plates VIII, IX) shows it in the early years of the seventeenth century.

The earlier German arquebus stocks provided only restricted space for inlay work, but as the butt widened out towards the end of the century, the opportunity for the inlay worker was greatly increased. Fine quality inlay can be seen on the stocks illustrated in Plates VI to IX, and on many other wheel-lock guns and pistols exhibited in the Museum.

In examining the inlay work and engraving it is necessary to remember that once a pattern book was acquired by a gunstocker it continued in use in his workshop over a very long period. We find, therefore, the designs of the sixteenth-century artists, Virgil Solis, Adriaen Collaert and Jost Amman being applied to wheel-lock gunstocks in Germany in the mid-seventeenth century and even later.

The work of the steel chisellers to the Bavarian Court, who were active during approximately the hundred years from about 1580 to 1680, is the best known of the German schools of fine steel working. These artists were primarily decorators and chiselled not only firearms but sword hilts, knife hafts, purse mounts, boxes and, in fact, whatever they were commissioned to do. Their work as applied to firearms is not very well represented in the Museum. There is a superbly chiselled lock (No. 3, Plate I) for a wheel-lock pistol dating from the beginning of the seventeenth century and another of later date (M.235–1919), but the magnificence of their richest productions can best be seen in the Wallace Collection and British Museum in London. The work of these Munich masters, the brothers Emanuel and Daniel Sadeler and their successor, Caspar Spät, probably represents the highest level ever achieved in the decorative treatment of arms, but there were other anonymous masters whose skill and taste came very near to them. The Electors of Saxony, the Dukes of Brunswick and, of course, the Hapsburg Emperors all had their own court gunsmiths who doubtless sought to equal the achievement of the Sadelers. The pair of pistols for which a design exists in the Museum (No. 8, Plate III) must, if they were ever executed, have been of a magnificence comparable with that of the weapons made for the Dukes of Bavaria.

The shape of the German gun stock is always a puzzle to the uninformed. It was not intended to be discharged from the shoulder, nor could it be held in such a way as to bring it to the shoulder. It was apparently held against the cheek, clear of the shoulder, and the recoil was taken with the arms. The stag-horn inlay on the stocks often shows a hunting scene with a hunter discharging his wheel-lock rifle in this way. The considerable weight of the barrel and stock of the typical German wheel-lock was sufficient to absorb much of the force of the recoil. Geographically this type of stock was confined to the German-speaking regions, Central Europe, Russia and Scandinavia. Elsewhere a butt with rounded lower edge was used, probably developed from the hooked butt of the match-lock petronel. The original form can be seen in No. 4, Plate II, and its more developed form in the heavy French gun, formerly in the personal armoury of King Louis XIII (No. 30, Plate XII).

The gunsmith of the sixteenth century devoted a great deal of ingenuity to improving the wheel-lock firearm. Not merely was rifling introduced, but double-and-triple-barrelled weapons, breech-loading guns and the superimposed load system were developed. The Museum collections include a number of these firearms incorporating technical improvements: amongst them is a gun dated 1581 with two locks and touch-holes from which two shots could be fired in succession (No. 6, Plate II), a wheel-lock gun with rifled barrel of 1605 (No. 17, Plate VI), a wheel-lock double-barrelled and a wheel-lock breech-loading pistol of about 1600 (No. 31, Plate XII and No. 23, Plate X); the system

of this last is the same as that of the two guns of Henry VIII in the Tower of London, one of which is dated 1537. Finally there is a wheel-lock, with gear-wheels so that the wheel is spanned automatically when the cock is drawn back, of about 1540 (No. 1, Plate I). Most of these pieces are of German origin.

The above remarks have been mainly confined to German wheel-lock firearms. Match-lock firearms had been manufactured in France, Holland and Italy during the sixteenth century in considerable numbers. Most of these were plain military arms, the rich ornament being reserved for wheel-lock sporting arms. However, a number of very finely inlaid German match-lock muskets exist and a French example is illustrated (No. 4, Plate II). It will be seen that the ornament, of horn, partly stained green, and mother of pearl, does not differ in general character from that in use in Germany at the same time. Subsequently, towards the end of the sixteenth century, the French gunstockers developed a style entirely of their own which showed no trace of German influence.

The production of Italian wheel-locks of the earliest type with external mainsprings does not seem to have been continued in Italy beyond the middle of the sixteenth century, though the construction was revived in Silesia for the lock of the Tschinke rifle (No. 33, Plate XIII). Italian wheel-locks of the second half of the sixteenth century are, as far as their mechanism is concerned, very similar to German wheel-locks of the same period. Italian production of wheel-locks in the sixteenth century cannot have been very large, since German manufactured wheel-lock firearms were imported both for the armoury at Venice and also for the Farnese armoury at Parma, now transferred to the Palace of Capodimonte, Naples.

Production of wheel-lock firearms probably began in Holland during the third quarter of the sixteenth century and in France slightly earlier. While the Dutch and the Italians copied the German form of lock the French gunsmiths developed their own form of wheel-lock which differed constructionally from the German system. Apart from a difference in the profile of the lock-plate, the French lock-plate being of smaller dimensions (No. 27, Plate XI), the main distinctions were, first that the mainspring was not attached to the lock-plate but was fixed independently by a pin passing through the stock, and secondly that the spindle on which the wheel rotated passed right through the stock and keyed into a recess cut in a steel side-plate inset in the stock on the opposite side to the lock. In general, it may be taken as a rule that the presence of this type of mechanism marks a firearm as French, but the pistol No. 11, Plate IV, which is of Nürnberg manufacture, presents an exception. The French double-barrelled pistol (No. 31, Plate XII) is, conversely, equipped with the German type of lock—for the good reason that it would be very difficult to accommodate two separately attached mainsprings within the narrow compass of a pistol stock.

No reference has yet been made to the snaphaunce lock which was widely used in Europe during the seventeenth century. Its source is uncertain, but the earliest extant examples are of Scandinavian origin and date from the middle of the sixteenth century. The lock was also produced in Germany, France, and Italy during the sixteenth century. There is a reference to a payment by the Stuttgart Court for a number of Landsknecht

9

muskets with snaphaunces in the year 1584, followed subsequently by further payments. Throughout the same period, the snaphaunce was also in use in England, Holland and Scotland. It was, however, mainly employed for plain military weapons in the sixteenth century, most of which have now perished. There exists a group of early seventeenth-century muskets with either match-lock or snaphaunce ignition, the stocks of which are profusely inlaid with engraved mother of pearl and with brass wire, in a manner similar to, but coarser than, the contemporary French work. Some of these muskets have the Amsterdam town mark on either lock or barrel but they were also a standard English type and many have survived in this country. There is a fork for a musket of this type in the Museum (2190–1855). During the second half of the seventeenth century, the snaphaunce system found little demand except for military purposes outside North Italy and Scotland.

THE SEVENTEENTH CENTURY

By the end of the sixteenth century, the gunmakers of Germany may be divided geographically into two main groups, those of the south and east, centred in Augsburg, Nürnberg, Munich and Dresden, and those of the west in the Aachen–Cologne area. While the gunsmiths of the south-eastern area during the first half of the seventeenth century followed on in the sixteenth century tradition, in the west a new grouping covering the Rhineland, Switzerland, Holland and Alsace–Lorraine becomes increasingly marked. The firearms made in this region represent a style half-way between the South German and the French manner. Wheel-lock pistols of this group are well represented in the Museum collection. The earliest is probably the Alsace–Lorraine type pistol, the stock of which is inlaid with rather coarsely-engraved mother of pearl and horn, interspersed with brass wire. This type of pistol is found in association with both the German and the French wheel-lock construction (No. 21, Plates VIII, IX). The ornament is derived from French or Dutch rather than the German patterns. The German influenced style can be seen in the pair of unsigned pistols (No. 38, Plates XIV, XV) with silver inlaid stocks. The designs engraved on the silver are copied from the engravings of Michel Le Blon, a German-born artist of Flemish extraction who was working in the Dutch city of Amsterdam. The Dutch type is represented by the plain pair of military pistols (M.632, 632a–1927). Finally, the Swiss version is represented by No. 37 (Plate XIV), a pair of wheel-lock pistols with brass lock-plates and barrels some of the ornamental details of which have also been taken from designs by Michel Le Blon. The Thirty Years War in Europe kept the gunsmiths busy and this area, which was outside the main area of operations, must have supplied large quantities of arms. In comparison with the French firearms, the pieces from the territories around the French northern borders are heavy and lacking in grace.

During the first quarter of the seventeenth century, the wheel-lock was made considerably lighter by a reduction in size of the lock-plate. At the same time the heavy wheel-cover which was secured to the lock-plate by two screws, one on each side, was in the case of pistols and carbines often replaced by a light hook, set on the left-hand side

of the wheel (No. 24, Plate X). The wheel-cover continued to be applied to the locks made for rifles and muskets and was often attractively decorated. In the Museum there are examples in pierced and engraved steel, pierced, engraved and gilt brass and in cast brass. Examples of silver and of enamelled copper are also known.

If the sixteenth century was dominated by the German gunsmiths, the seventeenth century saw the emergence of Paris as the home of the pre-eminent gunmakers of Europe. The French proved not only to be leaders in technical development but also in design, and there is a striking contrast between the clumsy German ball-butted *Puffer* (No. 10, Plate IV) and the elegant French wheel-lock pistols of the first half of the seventeenth century, the best of which are unfortunately not represented in the Museum. Some of the French wheel-lock pistols are so finely and delicately worked that they look quite unsuited to contain the discharge of so violent a medium as gunpowder. It was in the combination of technical efficiency with refinement of form that the French genius asserted itself. It is, moreover, to a craftsman at the French Court, Marin le Bourgeois, that the credit of developing the true flint-lock mechanism in the first decade or so of the seventeenth century should probably be given.

The French gunmakers were doubtless encouraged by the fact that King Louis XIII was from an early age interested in firearms. The diary of his medical attendant Jehan Héroard, mentions that in 1611, when he was ten years old, he already owned seven guns. By 1614 he had a collection of fifty and he was constantly purchasing more. One of his favourite occupations was to dismount and clean his firearms himself. His personal *Cabinet d'Armes*, containing hundreds of firearms, seems to have survived intact until the French Revolution. In 1673 his collection was inventoried by order of Louis XIV; and, as the inventory numbers were stamped on the stocks of each of the firearms, it is possible to identify the firearms which originally belonged to him. Eight of these are in the Museum collection and a number are in the Tower of London and the Wallace Collection. The exact fate of the *Cabinet d'Armes* after the Revolution is uncertain. It seems likely that at an earlier date the more decorative pieces had been separated from the plain arms of military type, of which Louis XIII had a number. The latter were placed in the Paris Arsenal where they remained until the occupation of Paris by the victorious allied troops after the Battle of Waterloo. Both the Prussian and the British removed quantities of firearms from the Arsenal as captured warlike stores. The trophies taken by the British, which included many firearms from the former royal *Cabinet d'Armes*, were originally placed in the Royal Artillery Museum at Woolwich, whence in recent years they have been transferred, in part to the Tower of London, and in part to the Victoria and Albert Museum.

The guns from Louis XIII's collection in this Museum show his interest in all kinds of firearms. They include a wheel-lock gun (No. 30, Plate XII), a wheel-lock double-barrelled pistol (No. 31, Plate XII) and a series of three guns, one with a snaphaunce (No. 40, Plate XVII) and two with flint-locks of the very earliest form (No. 41, Plate XVII), dating from the second quarter of the seventeenth century. Perhaps the most interesting is the small wheel-lock gun (No. 32, Plate XII) which must have been made for the

King during his childhood between 1610 and 1615. It has the characteristic wide flat butt of the late sixteenth century, but the three guns from the *Cabinet d'Armes* have already the club-shaped stock which is the prototype of the modern gunstock. Though it is not stamped with an Inventory number of the *Cabinet d'Armes*, the holster pistol (No. 54, Plate XXI) is believed to have come from the Paris Arsenal and, in view of its technical interest—it is equipped with a left- and right-hand lock arranged to fire two charges consecutively, one placed in front of the other—may well have been made for the French King.

While the French gunsmiths had perfected the true flint-lock during the early years of the seventeenth century, the Italian gunsmiths kept to the wheel-lock. The later Italian wheel-lock is almost indistinguishable from the South German prototype from which it was copied, but the gunsmiths of Northern Italy, mainly in Brescia and the valleys around that city, developed a particularly decorative form of pierced and chiselled steel work which has made their productions the most sought after of all seventeenth-century fire-arms. The Museum collections include a good series of Brescian firearms showing the various techniques of ornament executed in both steel and brass. The most delicate of the Brescian work is found in the flat panels of steel which were pierced and engraved with designs of animals, birds, monsters and figures enclosed within florid Baroque foliate scrollwork. This technique is well illustrated in the ornament of the wheel-lock pistol (No. 64, Plate XXIV). The Brescian steel-workers also displayed surpassing skill in chisel-ling figures in high relief, as in the snaphaunce lock (No. 65, Plate XXV). Alongside the high technical proficiency of the Brescian steel-workers, one finds craftsmen in villages widely spread in North Italy producing similar locks with much high-relief chiselling, coarsely executed with a rustic naïveté. Fortunately the North Italian craftsmen often signed their productions, so it is usually possible to attribute pieces to particular masters. Moreover, the various craftsmen who worked on the production of a firearm signed the parts for which they were individually responsible. It is usual to find a barrel-smith's signature and a locksmith's signature on an Italian firearm. In some cases the maker of the mounts or of the stock has added his signature as well. About the middle of the seventeenth century a form of snaphaunce lock replaced the wheel-lock in Northern Italy. This development gave exceptional opportunity to the Brescian craftsmen who were able to chisel both the cock and the arm of the steel in the round in the form of human figures or monsters. It is interesting to note that whereas the characteristic low relief chiselled ornament of the Brescian gunstock mounters was entirely indigenous, the design of some of the chiselled cocks seems to have been derived from the pattern book of François Marcou, published in Paris about the middle of the seventeenth century. The fine quality of the Italian steel-chiselling, piercing and engraving was widely recognized in the seven-teenth century, and most of the European princes, including Louis XIII of France, acquired examples for their collections. The Brescian genius lay rather in fine steel working and, in particular, in cutting the surface of the gun stocks with extraordinary precision to receive the pierced steel tracery, than in the technical qualities of lock-making; and a Brescian lock, seen from the inside, shows little of the precision of the best German or French locks

of the same period. Those who could not afford to buy Brescian pistols had a pair of Brescian barrels mounted up by a local gunmaker, and there was a considerable export trade in finished barrels from Brescia. Most of the Brescian barrels were stamped with the name Lazarino Cominazzo, perhaps more by way of a trade mark than a signature, for it seems hardly possible that all the barrels signed in this way could have been produced in one workshop. Such was the high reputation of the Cominazzo family as barrel-smiths that many of their rivals outside Italy fraudulently stamped the Cominazzo signature on their own productions. Such forgeries are usually recognizable by reason of slight variations in the lettering and placing of the name. Though members of the family were pre-eminently barrel-smiths, one at least of them sold firearms, as we know from the often cited passage in Evelyn's diary in which he states that he bought a fine carbine of 'old Lazarino Cominazzo'. These carbines, which were intended to be carried at the saddle-bow, are represented by a very fine example in the Museum with two cocks (pyrites holders) (No. 55, Plate XXI). The iron pyrites which was used to produce the sparks to ignite the priming powder was a much softer material than the flint that was used with the snaphaunce or flint-lock systems and a reserve cock with a second piece of pyrites was likely to be of use in emergency.

The North Italian locksmiths, having abandoned the wheel-lock shortly before the middle of the seventeenth century, adopted the French type of lock in which the main-spring was placed on the inside of the lock-plate and the scear worked vertically, engaging in a recess cut in the tumbler. This mechanism was combined at first with the snaphaunce system by which the pancover and steel were independent elements connected by a link. Very soon after, or possibly at the same time, the true flint lock steel was introduced, in which the steel and the pancover were combined in one. The two types continued in use in North and Central Italy up to the end of the eighteenth century, and even later. The snaphaunce system with independent pancover and steel, though less compact and re-quiring an extra motion in loading, had the advantage that no safety catch was required on the cocking mechanism, since the lock could be made secure when cocked and primed by turning back the steel.

In Southern Italy a type of chiselled ornament was adopted, by comparison with which even the florid Brescian style seems restrained. The lock was chiselled with grotesque masks carved in very high relief, and with figure sculpture executed in the round. This style of ornament has been associated with Naples, mainly because somewhat similar designs are found on the cup hilts of rapiers signed by Neapolitan masters. The double lock (No. 46, Plate XIX) shows it in its most extreme form. When the wheel-lock was given up, the gunmakers of Central and South Italy adopted the Roman snap-lock. This closely resembled the *Miquelet* lock which was evolved in Spain in the course of the sixteenth century and the system may have been introduced into Italy through the Spanish rulers of Naples and Southern Italy. It may, however, have been developed independently by Central Italian gunmakers. The *Miquelet* lock in both its Spanish and Italian versions had a combined steel and pancover, thus improving on the sixteenth-century snaphaunce. The *Miquelet* lock continued in use both in Italy and Spain until the late eighteenth

century, and in Spain even into the nineteenth century. The Museum has an extensive collection of Italian gunlocks of northern and southern types and all the mechanisms referred to above are represented in numerous versions. Particularly noteworthy are the locks No. 65 (Plate XXV), M.546–1924 signed by Michele Lorenzoni of Florence, and No. 58 (Plate XXII), signed by Domenico Santi of Montealboddo.

The existence of numbers of unmounted locks of Italian origin is possibly due to the fact that gunmakers ordered them in quantity from the locksmiths and they were held in stock until needed. The unmounted locks were probably overtaken by some change in fashion or technical improvement before coming into use.

During the second quarter of the seventeenth century, a fashion for austerity in design and decoration of firearms became apparent in Germany and in Western Europe. Instead of the elaborately inlaid stocks which had been popular in the Low Countries, Northern France and Germany, ebony or a soft wood stained and varnished to resemble ebony were more frequently used. Instead of the chiselled, blued and gilt mounts found on the finest German firearms, the mounts were restricted to bands around the butt and the fore-end, made of thin sheet silver or of gilt copper, engraved with some appropriate design. The silver-mounted group is represented in the Museum by a pair (No. 38, Plates XIV, XV) while the pair of pistols (No. 37, Plate XIV) with mounts of gilt copper show another aspect of this trend towards sobriety in ornament. It was only in the larger gun-making centres of Europe that such changes in fashion had any real effect. In the peripheral territories, in Italy, Spain and Austria, they passed unnoticed. The court workshop of the Electors of Bavaria continued also to work in the same manner that had been devised by Emanuel Sadeler some thirty years earlier.

While the elaborate bone inlay on gunstocks was becoming old-fashioned in Western Germany by the middle of the seventeenth century, in eastern Germany, Austria and Poland it has a much longer life. One particular school of gunmakers produced a wide variety of firearms, all decorated in similar manner. They are not signed, nor is there any barrel-smith's stamp on the barrels, but it has recently been established that they were produced in the Silesian town of Teschen. The name of Tschinke, given to the light wheel-lock birding rifle which was a speciality of this gun-making school, is in fact derived from the Polish version of Teschen. The stocks of the Teschen firearms are profusely but coarsely inlaid with engraved bone and mother of pearl. The locks and barrels are decorated with panels of gilt punched work, the remaining surface being blued. The Museum collection includes two Tschinkes (No. 33, Plate XIII) a wheel-lock rifle (M.101–1930) and a flint-lock holster pistol (No. 75, Plate XXX) all decorated in the same manner and evidently dating from the second half of the seventeenth century.

When the German gunmakers abandoned bone inlay during the second half of the seventeenth century, they turned to other forms of ornament. The stocks were carved with figure subjects or scrollwork (7821–1861), inlaid with steel wire (M.637–1927), or overlaid with plaques of staghorn or ivory. A series of firearms with stocks overlaid with plaques of ivory carved in such high relief as to make them more suitable for the *Kunstkabinett* than the chase were made by the Swabian carver, Michael Maucher, for the

Electors of Bavaria. A similar rifle, also signed by Maucher, from the Museum collection is shown in Plates XIII and XVI (No. 35). It has the additional feature of being a breech-loading arm, and must have been intended for use in spite of the delicate nature of the ornament. About the middle of the seventeenth century, the form of the wheel-lock was changed in that the wheel was accommodated on the interior, instead of the exterior, of the lock (No. 87, Plate XXXVI). A more streamlined effect is achieved on a lock (M.537–1924) dating from the third quarter of the seventeenth century, signed Georg Kog (presumably Georg Koch of Vienna). Here the cock spring as well as the wheel are accommodated on the interior of the lock-plate and the arm of the cock is flattened so that it is flush with the lock face. This last lock is very finely engraved with hunting subjects enclosed within foliage derived from the *Neues Groteschgen Büchlein* of the Prague engraver Johann Smischek, a work which was much in favour as a source for the ornament of gun-furniture. The steel chisellers of the Munich school also made use of this particular pattern book as a source for their gun ornament about the middle of the seventeenth century.

It is, perhaps, no coincidence that the supremacy of the French gunmakers in the latter part of the seventeenth century corresponded in time with the dominating position of France under the rule of Louis XIV in European politics. An indication of the importance attached to fine firearms in the seventeenth century can be gained from the fact that when, in 1673, Louis XIV wished to make a splendid gift to Charles XI, King of Sweden, he presented him with a series of firearms, all by the foremost Parisian gunsmiths, in addition to twelve richly caparisoned horses. Six guns, five brace of pistols and one single pistol from this gift are still preserved in the Stockholm Royal Armoury.

As long as gunstocks had been inlaid with horn, there had been little appreciation of the natural qualities of the wood of which the stocks were composed. Until the middle of the seventeenth century, wood stocks were covered with ivory or with tortoiseshell, or stained to resemble ebony, but little attempt was made to exploit the figure of the wood. The main exceptions to this rule were the stocks of palisander or other exotic woods which were constructed by the Munich gunstockers, Hieronymus Borstorffer, father and son, for the guns decorated by the Sadelers. During the third quarter of the seventeenth century, we find stocks made of finely-figured walnut. The Parisian gunmakers were probably the first to appreciate the decorative possibilities of a finely-figured stock, but the fashion spread rapidly across Europe, and the Museum can show examples from England in the West to Eger in Bohemia in the East. It is true that inlay of silver wire is found on the finest stocks of the late seventeenth century, but this was rarely so profuse as to obscure the figure of the wood.

It was not easy to find pieces of finely-figured wood of dimensions large enough to provide a gun or even a pistol stock, and if the stocks are carefully examined, the fore ends will often be found to have been spliced on. The figure was sometimes artificially heightened by slightly charring the surface over a flame, which gave the contrast between light and dark that is so characteristic of the late seventeenth century. The stocks of the finest guns were made of root walnut, while maple was used for the cheaper lines.

15

A feature of French firearms of the seventeenth century, particularly of the middle decades, was the fine engraved ornament with which the steel parts were decorated. Exquisite work was done by Jacquinet, who engraved the copper-plates of the two books of gunmakers' ornament issued by François Marcou and Thuraine et Le Hollandois about 1650–60 (Plates XVIII and XXII). Unfortunately, engraving on steel is very easily destroyed through rust oxidization and few guns have survived outside the hereditary armouries of the European royal families, which show this engraved ornament in anything approaching its original condition. Pulls taken by the engraver from engraved gun furniture are illustrated in Plate XX and show engraving in its original state. The ornament consisted at first of grotesque monsters amidst foliage and hunting subjects. Subsequently, during the reign of Louis XIV (No. 52, Plate XX), subjects drawn from classical history were increasingly employed. The lock-plates of the mid-seventeenth century were flat and offered therefore a most suitable surface for engraving. Between 1660 and 1670 Parisian fashion favoured lock-plates with a rounded surface, and the latter form remained fashionable until the end of the century. Provincial and foreign gunmakers were slower to follow a new fashion than those of the capital city of France, but through the medium of the pattern books, the Paris fashions became known and were emulated throughout Europe.

En suite with the lock-plate, the other mounts, side-plate, trigger guard and escutcheon were after about 1660 executed in relief instead of in the flat. This development very much restricted the scope of the engraver but it did on the other hand create new opportunities for the steel chiseller. After the introduction of the rounded forms, we find finely-chiselled steel mounts being produced all over Western Europe. Examples in the Museum collections of this period are signed by makers in London, Turin, Sedan and Liège. One of the most attractive features of the firearms of the last quarter of the seventeenth and the first half of the eighteenth centuries was the exploitation of the decorative possibilities of the side-plate, the strip of metal set into the stock on the side opposite to the lock. Its function was merely to prevent the lock-screws (in English gunmaking terminology, side nails), which had to be very firmly screwed up, from biting into the wood of the stock. In this period we find it rendered in most attractive combinations of Baroque foliate scroll-work, human figures, serpents, etc. (No. 53, Plate XX).

The dating of the flint locks of the second half of the seventeenth century can be established by reference to the degree of elaboration in the design of the side-plate and the form of the fire-steel. The breast of the mid-seventeenth century steel is carved with a single acanthus leaf, subsequently a small wart-like projection is substituted. As the century advanced, this wart develops foliation and finally assumes a form resembling the conventional representation of a bomb.

During the second half of the seventeenth century and the early eighteenth century, the Parisian pattern books secured so widespread a distribution that an international style of design grew up, based on Parisian prototypes. Even in Spain and Italy, which had hitherto remained consistently faithful to their national styles, gunmakers made use of the two Simonin pattern books published in Paris in 1685 and 1693 (Plate XXVIII). An outstand-

ing example is the three-barrelled revolving pistol by Michele Lorenzoni of Florence (No. 78, Plate XXXI) which might at first sight pass for the work of a Parisian master. In the early eighteenth century, the force of Parisian fashion was so strongly felt that we find gunmakers all over Northern Europe signing their locks in French, as in the case of the very French-looking piece from the armoury of the Grand Duke Ernst August of Saxe-Weimar, signed 'Tanner a Gotha 1724' (No. 88, Plates XXXVI, XXXVII).

Many fine firearms were produced in the seventeenth century on the north-eastern borders of France in the province of Lorraine, particularly in the city of Metz. During the second half of the century there was an important gunmaking industry in the northern French town of Sedan, where such distinguished makers as Ezechias Colas, Daniel Martin, Gabriel Gourinal and Soiron were at work. The last of these makers is represented in the Museum by a flint-lock holster pistol (M.11–1949). Until 1642 Sedan was the capital of an independent principality of the Dukes of Bouillon, Princes of Sedan, and was a flourishing centre of the crafts. After its incorporation in the Kingdom of France in that year its importance waned, and the Revocation of the Edict of Nantes in 1685 drove away its craftsmen, reducing it to the status of a provincial town. It was not only in the northern provinces that fine firearms were produced; there were also important gunmaking schools on the Loire in Tours and Angers and in Savoy.

About the middle of the seventeenth century a group of pistols with finely-chiselled mounts made in France or Flanders emerges. The locks, barrels and mounts are chiselled with battle scenes or with profile heads in costume of the mid-seventeenth century; in order to provide the maximum space for chiselled ornament the steel-spring is fixed to the inside of the lock-plate. Of this group, the Museum possesses a detached lock (M.547–1924), the chiselled ornament after Marcou, a detached barrel (M.687–1927) and a single pistol, signed 'Fabri à Liège' (M.9–1949). This last piece is one of the later examples of the group, dating from circa 1670–80. It still has, however, the characteristic profile heads chiselled on the pommel, and the fact that it is signed by a Liège maker gives it documentary value as the earlier examples in the group are all unsigned, and have, for this reason, not hitherto been attributed to any definite place of origin. The Liège gunmakers produced work of high quality during the seventeenth and eighteenth centuries and further examples from Liège workshops will be referred to below.

Few references have hitherto been made to English gunmaking, not because it did not exist, but because its earlier phases are not represented in the Museum. Some of the most important of the gunmakers working in England in the seventeenth century were foreign immigrants; Harman Barne, gunmaker to Prince Rupert and later to Charles II, James Ermendinger and Kaspar Kalthoff, assistant to the Earl of Worcester in his famous experiments and inventor of a breech-loading magazine rifle, were German; and Andrew Dolep, gunmaker to Lord Dartmouth, was a Dutchman. The persecution of French Protestants culminating in the Revocation of the Edict of Nantes in 1685 brought a number of highly skilled gunmakers to England in the decade 1680–1690. The most important was Pierre Monlong, who was appointed Gunmaker-in-Ordinary to William III. He made, presumably for the King, what are probably the most lavishly enriched pair of pistols ever

produced in this country. Most of the other Huguenot gunmakers are known only from documentary records, but firearms of outstanding quality by Jacques Gorgo, Pierre Deverre and Landreville still exist to show their skill.

The Civil War in England led to a great interest in accurate military weapons, and the 'turn-off' gun or pistol was developed to meet this demand. This type is represented in the Museum by a flint-lock holster pistol, signed Fisher, dating from about 1680 (No. 70, Plate XXIX). The barrel, which is rifled, unscrews at the breech, permitting the charge and bullet to be inserted directly in the chamber. A bullet of diameter very slightly larger than the bore of the barrel was employed, thus ensuring, firstly, that the ball did not leave the chamber until the charge was fully ignited, and secondly that it fitted the barrel so closely that it could not fail to take the rifling. These pistols took a very heavy charge, the chamber being about the same size as that of a modern service rifle. In order to resist the force of the discharge, the walls of the barrel were made of thicker metal than those of contemporary muzzle-loading pistols, and the walls of the reinforce may be as much as $\frac{5}{16}$ in. thick. It has been credibly suggested that these rifled pistols were designed to pierce the so-called bullet-proof breastplates which were still worn by cuirassiers during the Civil Wars. Technically, they were more efficient than any of the muzzle-loading firearms produced in England during the first three-quarters of the eighteenth century. During the hundred years from about 1680 to 1780, there seems to have been little interest in devising pistols which could achieve high velocity and therefore, accuracy and power of penetration. Most of the seventeenth-century rifled pistols were full-length holster pistols intended for use by cavalry and the reason for their desuetude may have been an alteration in the tactical handling of mounted troops involving the substitution of charging with the sword for long-distance firing. The earliest known English example, dating from about 1650, is signed by Harman Barne, and there is no doubt that they were more popular in England than elsewhere. Dutch, French and Austrian examples are known—the last combined with wheel-lock ignition—but they are far more rare than those by English makers. It is a surprising fact that no example of the turn-off barrel is shown in the French gunmakers' pattern books of the mid-seventeenth century; this suggests that there can have been little demand for them on the Continent at the time. This system retained its popularity in England throughout the eighteenth century, but mainly for small-size pistols with smooth-bore barrels. The eighteenth-century type is represented by the Turvey pistol (No. 72, Plate XXIX). The eighteenth-century examples were not military pistols, but were intended for personal protection. They lack, therefore, the feature of the Fisher pistol, namely the link which attached the barrel to the stock when unscrewed and thus made loading on horseback possible.

While the Kalthoff family, one of whom worked for a while in England, had been the first to develop an effective breech-loading magazine system, the English gunmakers with the exception of Harman Barne did not take up its manufacture. Another system, the invention of which is usually attributed to the Florentine gunmaker, Michele Lorenzoni, was adopted by several English makers. It is represented in the Museum by a particularly fine example, signed by John Cookson of London (No. 67, Plate XXVII). A repeating

system, possibly identical with that of this gun was patented in 1664 by the London gun-maker, Abraham Hill. Magazine guns of this type were produced by other London gun-smiths about the 1670's and 1680's evidently without regard to Hill's patent. During the eighteenth century this system was occasionally used on pistols. A characteristic Birming-ham-made pocket pistol, the lock with the spurious signature 'London', dating from about 1780 (M.683–1927) shows a simplified version of the system.

THE EIGHTEENTH CENTURY

The end of the seventeenth century saw a turn of fashion away from the rounded surfaces introduced about forty years earlier. Two Parisian pattern books by Nicholas Guérard and De Lacollombe (Nos. 80 and 81, Plate XXXII) respectively helped to disseminate the new ideas throughout Western Europe. At the same time convenience and economy led to the use of less decorative but more solid walnut stocks instead of the very short grained burr and root wood which had been employed for all the best quality weapons. The fact that a number of fine-quality pistols of seventeenth-century date have been restocked in the eighteenth century in plain straight-grained walnut testifies to the short life of the decorative burr wood stocks. Another innovation was the gilding of the ground of the chiselled steel on the best-quality pieces. These three developments wrought a great change in the flint-lock gun or pistol, which became considerably more sumptuous in appearance. Its ornament was now immediately obvious to the eye and no longer needed to be sought out. The Régence ornament which is found in the Guérard and De Lacollombe pattern books was derived from the designs of Jean Bérain the Younger. Consisting of strapwork, acanthus foliage, trophies of arms and grotesque masks, it was peculiarly suitable for application to firearms. At the same time, something of the elegance of line, which had been sacrificed when the heavier forms and relief carving of the Simonin style was adopted, was recovered, at any rate by the Parisian gunsmiths. The Museum collections do not as yet include a fine Parisian piece of the early eighteenth century, but the effect of the new style can be studied in firearms made outside France under the influence of the new pattern books. The brace of holster pistols signed by I. I. Behr (No. 91, Plate XXXVIII), attribut-able on internal evidence to Liège, show a western version of the style, while a Southern European version can be seen in the single holster pistol made in the Royal Armoury of the Kings of Sardinia at Turin (No. 92, Plate XXXVIII). The same style, but with engraved instead of chiselled ornament, and showing the purest Parisian manner is repre-sented by the fowling-piece made by a member of the Tanner family for the Saxon court (No. 88, Plates XXXVI and XXXVII). The mounts of the last mentioned are of silver, a metal which was much more extensively used for gun furniture about the close of the seventeenth century. This meant a great saving in labour for the gunmakers, for whereas the steel mounts had to be forged, filed to shape and finally chiselled and engraved, silver mounts were cast, and, if necessary, slightly chiselled and then they were ready for fitting. In England, the gunmaker did not make silver mounts, but bought them in quantity from silversmiths in London and Birmingham who specialized in their manufacture. The

grotesque mask butt on the screw-barrelled pistol by W. Turvey (No. 72, Plate XXIX) is, for instance, of a standard type that was used by most of the eighteenth-century gunmakers in London for this class of weapon. Until about 1780 silver was increasingly employed for better quality arms, particularly in England, where great skill was shown in combining delicate silver inlay work in the wood stocks with rather massive silver mounts. One of the most magnificent examples of this technique of ornament is the air-gun signed by Kolbe and believed to have been made for George II (No. 94, Plates XXXIII, XXXIX and XL). Kolbe was, as his name suggests, a German and there is no doubt that this air-gun was made only shortly after he left his home town of Suhl for England. Nevertheless, the chiselling and embossing of the silver of the mounts must be the work of English craftsmen, for they are of a quality beyond that likely to be achieved by even the most gifted of gunmakers. It is probable that Kolbe called in the assistance of a silver chaser to carry out the silver-work. The great weight of the silver ornament on this gun makes it, incidentally, heavy and clumsy to use. Its decoration is not copied slavishly from a pattern book but has been designed individually. This Kolbe air-gun is an exceptional weapon made for a royal patron, but the same elements of ornament, employed on a less lavish scale, could produce particularly attractive results, as on the fowling-piece by Wilson of 1749 (No. 93, Plates XXXIX and XL) or the cannon-barrelled pistol by W. Turvey (No. 72, Plate XXIX).

An unusual pair of pistols by the Liège maker, Devillers, have stocks entirely of silver (No. 77, Plate XXXI). They are of the cannon-barrel type and are rifled but there is no provision for the barrels to unscrew. They point to the high quality of Liège gun-making in the first half of the eighteenth century. The Liège makers are best known for their production of military and trade guns but they also produced some highly decorative arms. While in France and England steel or silver mounts were much favoured, in the Low Countries, in Southern Germany, in Austria and in what is now Czecho-Slovakia, mounts of gilt brass or bronze were more usual. The finest work in this material was done by the gunmakers of Austria and of Bavaria, and firearms made for the German princes have mounts of brass or bronze, cast and then finely chiselled and gilt. The use of gilt brass, which contrasted most effectively with the walnut stocks, coincided in period with the last phases of Baroque art in Central Europe. We find the late Baroque motives of interlacing strapwork, delicate acanthus foliage and figure subjects taken from classical mythology fully exploited in the design of these mounts. A wheel-lock rifle from Munich (No. 87, Plate XXXVI) shows the South German style, while a pair of pistols (No. 76, Plate XXX) and a flint-lock rifle (M.192–1951) show the slightly coarser but colourful manner of the Prague and Carlsbad workshops respectively. The popularity of gilt brass mounts in the Low Countries can be attributed, at any rate as far as the Austrian Netherlands were concerned, to Austrian influence: thus the pair of Liège pistols (No. 77, Plate XXXI) were made for a Hungarian nobleman. The use of gilt brass or bronze in Liège and in Central Europe must be distinguished from the practice in England, where brass mounts were rarely gilt and were mostly reserved for second-quality arms. The wheel-lock continued in use as a sporting and target weapon in Germany long after it had been abandoned

elsewhere. The latest example in the Museum (No. 87, Plate XXXVI) dates from the early years of the eighteenth century, but there are finely-chiselled detached locks which were made as late as the second quarter of the eighteenth century. During the early decades of the eighteenth century, steel chiselling of very high quality was produced by a number of craftsmen working in Bavaria and in Austria. There is a representative series of these wheel-locks in the Museum, the best examples bear the signatures of Nicolaus Koch of Vienna and C. Öfner of Innsbruck respectively (M.538-1924 and No. 57, Plate XXII). The latter is of particular interest in that it is also signed by the chiseller with his initials I.M.K. The wars of liberation against the Turks often provide themes for the decoration of the locks from Eastern Europe. The lock of the Christoph Frey rifle (No. 87, Plate XXXVI) is chiselled and engraved with a combat scene between European and Turkish cavalry, while the detached wheel-lock (719-1877), signed by M. Muck of Brunn in Moravia, is engraved with a representation of the defeat of the Turks before the walls of Belgrade on 22 August 1717.

The Museum is fortunate in possessing outstanding examples of the gunsmiths' art of France and Germany as well as of England, dating from the middle years of the eighteenth century. The pistols (No. 90, Plates XXXVII and XXXVIII) were made for Louis XV, King of France, and must be amongst the most richly ornamented firearms in existence. They belong to the late Rococo period of about 1750-60 when rather inappropriate sprigs of naturalistic flowers were beginning to intrude amongst the flame-like scrolls of the earlier and purer style. Their creator has exploited every available technique of ornament, but in spite of this ornament that runs riot over their surface, they have a beauty of form that is worthy of the great traditions of Parisian gunmaking. It is essential to remember their colour scheme, the lock and mounts of bright steel against a gold ground, the barrels partly encrusted with gold against a brilliant blue ground, and finally the inlay of gold wire in the richly-figured walnut stocks.

The Saxon court had always been great patrons of the makers of fine arms and armour, and in the eighteenth century they gave many commissions for firearms to the family of Stockmar, three members of which held in succession the office of *Hofgraveur* at the Saxon court. The Stockmars were one of the few gunmaking families who succeeded in realizing some of the more extravagant ideas of the French designers of the eighteenth century. The Rococo style gave unlimited scope for improvisation, and the Stockmar guns are not drawn literally from the pattern book. While Stockmar's designs include figure subjects, the main element consists of the flame-like motifs that are so typical of German rococo. These are chiselled in the steel mounts against a matt gold ground, carved in the walnut stock, and inlaid in silver wire. The fowling piece (No. 89, Plates XXXVI and XXXVII) shows their style at its best.

During the second half of the eighteenth century, numerous improvements in the methods of manufacture of gun barrels and in the design of the lock made the flint-lock a highly efficient weapon. During the last two or three decades of the century, the practice of duelling with the pistol was introduced, and a pair of duelling pistols seems to have been a necessary part of the equipment of a gentleman. As the technical effectiveness of

the firearm increased, its decorative qualities ceased to be of importance. Instead of chiselled and gilt steel, silver or ormolu, the mounts were made of blued steel which had the practical advantage of not reflecting the light, but offered little scope for ornament. During the seventeenth century and the first three-quarters of the eighteenth century, English gunmakers had not enjoyed any great fame outside the British Isles, but the advent of the duelling pistol gave them an opportunity which they did not fail to take. The English duelling pistol was a weapon of extreme accuracy and its lock-work was made with a precision which had never before been achieved in the history of firearms; its development during the last years of the eighteenth century is associated with the names such as D. Egg, H. W. Mortimer, H. Nock and the brothers, John and Joseph Manton.

THE NINETEENTH CENTURY

Nineteenth-century firearms hardly find a place in a Museum of applied art but the last phase of the flint-lock in England is represented by a fowling piece by Durs Egg with silver mounts bearing the London Hallmark for 1801 (No. 98, Plate XLII) and a gold damascened barrel and a pair of double-barrelled pocket pistols by Joseph Egg with London Hallmark for 1823 (No. 100, Plate XLIII). These pistols are of the very highest quality as regards both construction and finish. That they were highly regarded is evident from the fact that they are partly mounted in gold. An unusual feature is the presence of the mainspring on the outside of the lock. This was not a new development and had been introduced for double-barrelled under and over pistols during the first half of the eighteenth century. By placing the mainsprings in this position the width of the pistols could be reduced so that they might more conveniently be accommodated in the pocket.

In France, Nicholas Noel Boutet, Director of the Arms Factory at Versailles under Louis XVI and subsequently during the Directoire and Empire periods, succeeded in applying many features from the rich stock of Empire ornament to his firearms while at the same time incorporating many technical improvements in their design. His productions, most of which were presentation weapons for Napoleonic officers or for foreign princes, were of the highest artistic merit. He is represented in the Museum by a pair of rifled target pistols made about 1820 in the last years of his working life (No. 101, Plate XLIII). These are of very sober design in comparison with the presentation arms he made during the Napoleonic period, but illustrate the revolution he introduced in the design of firearms.

APPENDIX: DESCRIPTION OF MECHANISMS USED FROM THE SIXTEENTH TO EIGHTEENTH CENTURIES

THE MATCH-LOCK (*Figs. 1 and 2*)

The match-lock consisted of a forked match-holder, cock or serpentine (A), in which the slow match was fixed by means of a small thumb-screw (B), and a lever or scear (C) pivoted upon the inside of the lock-plate and linked to the serpentine in such a manner that when its hindmost end was raised the serpentine was made to swing with a circular motion, bringing the lighted end of the match down upon the flash-pan. This was filled with fine gunpowder and communicated with the charge in the barrel by means of a small vent or touch-hole bored through the side wall of the breech. The scear and serpentine were set in motion by means of a long trigger, similar in form to that of a crossbow, which was screwed into the hindmost end of the scear, whilst a scear-spring (D), screwed or pinned to the inside of the lock-plate, and pressing against the foremost end of the scear, served to hold the lighted match clear of the flash-pan until the trigger was pressed. The flash-pan was at first a part not of the lock but of the barrel, being either brazed or welded into its breech. It was protected by a hinged pan-cover, which served to hold the priming in position. This was swung open horizontally immediately before firing.

When loading, the first motion was to remove the match from the serpentine, and to grasp it in the left hand, the lighted ends being kept well away from the powder during the process of loading. The piece was then 'ordered', the musketeer placing the butt upon the ground and holding the barrel in his left hand, while with his right he took his powder flask of coarse gunpowder from his waist-belt and measured out a charge of gunpowder. This operation was performed by holding the flask upside down and pressing a thumb-catch which allowed an exact charge of powder to flow into the nozzle. Then, releasing the thumb-catch and pressing another catch which opened the mouth of the nozzle, he poured the charge into the barrel of his musket following it up with a fragment of wadding, and a bullet taken from his pouch, and finally ramming the charge home with a stroke of his ramrod, which he withdrew from its slot in the musket stock for this purpose.

These preliminaries completed, it remained only to prime the piece, filling its flash-pan with a fine-grained powder from his priming flask, closing the pan and blowing away any loose powder from the cover. He then returned the match to the serpentine and fixed it with a turn of the thumbscrew. The piece was then ready for discharge. If the musketeer was not able to discharge his piece immediately, it was necessary for him to readjust frequently his match in the serpentine so that the projecting end should be of the right length to fall squarely in the pan upon his pressing the trigger, and sometimes to re-light the match from its other end, which was kept burning for this purpose, if it should burn down to the serpentine and go out.

During the sixteenth century, the match 'tricker' lock (*Fig. 2*) was introduced. This was an improvement on the first form of match-lock. In this case, the flash-pan, the pan-cover and a shield (E) intended to protect the eye of the musketeer from the flash of his priming were attached to the lock. Further, the scear and the serpentine were set in motion by a separate trigger, which was protected by a trigger guard in the modern fashion.

THE WHEEL-LOCK (*Fig. 3*)

In the wheel-lock the lighted match is dispensed with, the priming being ignited by means of a piece of iron pyrites (A), held in contact with the serrated edge of a steel wheel (B), which is rotated by means of a powerful 'V' mainspring (C) attached to the inner side of the lock-plate. In order to prepare the lock for firing, it is necessary to fit a key upon the squared end of the spindle (D) on which this wheel revolves, and to turn the spindle in a clockwise direction, winding up a short steel chain (E) which connects the spindle with the free end of the mainspring. When three-quarters of a revolution have been completed, a scear (F) fixed upon the inside of the lock-plate engages in a recess cut in the inner surface of the wheel and so secures it in position, with the spring bent and the chain wound tightly round the spindle (D). The flash-pan (H), which is attached to the lock-plate and pierced at the bottom to admit the serrated edge of the wheel, is then primed in the usual manner, the pan-cover (I) closed, and the cock or dog-head (J) holding in its jaws a piece of iron-pyrites lowered so that it rests on the upper surface of the pan-cover. It is held in contact with the latter by means of a strong spring (K). When the trigger is pressed, it draws back the scear horizontally, freeing the wheel. The latter, impelled by the force of the mainspring, begins to turn rapidly, and at the same time a cam attached to the spindle strikes violently against a steel arm (L) pivoting at its lower end on the lower part of the lock-plate and attached at its upper end to the pan-cover. The arm is forced back, drawing back the pan-cover and allowing the piece of iron-pyrites to fall upon the serrated edge of the wheel as it revolves at full speed, striking a shower of sparks and igniting the priming powder in the flash-pan. The pan-cover itself is secured in the open position by a spring catch (M) and so held until the pan is reprimed.

THE DUTCH SNAPHAUNCE (*Fig. 4*)

In the Dutch or German version of the snaphaunce lock, the cock (A), bearing a piece of flint in its jaws, strikes upon a steel (B), thus producing a spark to ignite the priming. In order to prepare the piece for discharge, the pan (C) is primed, the pan-cover closed and the cock drawn back to 'set' position. The Dutch snaphaunce scear (D) does not (as was the case with the later locks) engage in a notch cut upon a tumbler, but projects through the lock-plate, as does the scear of the wheel-lock, and acts directly upon the cock, catching upon a lug or tail or engaging in a slot cut in its inner face (E). No half-cock is provided, since it is possible for the snaphaunce piece to be carried, when fully primed and loaded, with its cock set, but with its steel raised clear of the flash-pan, in which position it is impossible for the lock to give fire by accident. To prepare the piece for discharge it is sufficient to lower the steel on to the pan-cover. When the trigger is pressed, the scear is withdrawn horizontally through the opening in the lock-plate, freeing the tail of the cock, which is forced down upon the steel by the action of the mainspring (F). The mainspring is placed inside the lock, and exerts its force on the cock by means of the tumbler (G), a steel block keyed or pinned to the cock-spindle (H) on the inner face of the lock. The tumbler in turn is linked to the pan-cover by an arm (I) on the inner face of the lock. As the tumbler turns, the arm moves over, forcing back the pan-cover at the same time as the flint strikes sparks from the steel.

THE ENGLISH LOCK (*Fig. 5*)

In England a lock was introduced during the first half of the seventeenth century which incorporated the main features of the snaphaunce firing mechanism, in particular the scear acting

horizontally through a hole cut in the lock-plate. In this lock the pan-cover is, however, combined with the steel. The combined steel and pan-cover (A) (hammer, battery or frizzen) consists of a hinged cover, working upon a screw set in the lock-plate, and held in position by a light V-spring placed either inside or outside the plate (B). From the cover a curved steel rises at such an angle that the flint held in the jaws of the cock should strike it with the scraping movement required to produce fire, the pan-cover spring fulfilling the double function of keeping the pan firmly closed until the moment of firing, and causing the pan-cover when struck by the flint to offer sufficient resistance. The sliding pan-cover and also the link connecting it with the tumbler could now be dispensed with, but it was necessary to devise a safety position for the cock to enable the gun to be carried primed and loaded without danger. This safety position consists of a half-cock bent or step (C) upon the tumbler, in which the scear (D) was engaged when it was desired to set the lock in the half-cock or safety position, with the cock partly raised and the pan closed. In addition to the use of a half-cock bent upon the tumbler a certain number of English locks were fitted with an additional safety device in the form of a hook-shaped catch fixed to the outside of the lock-plate. This catch engages in a recess cut in the tail of the cock when the latter is drawn back just beyond the half-cock position. The catch had to be drawn back with the thumb before the piece could be fired. This form of safety device is commonly called a dog-catch and locks which are so fitted are sometimes known as dog-locks. In the later forms of the English flint-lock, dating from the Civil War period, the scear, though still working horizontally, no longer penetrates through the lock-plate but engages in two bents cut in the tumbler. This lock had a very short life in England as it was almost immediately replaced by the French flint-lock. It is not at present represented in the Museum collection.

THE SCANDINAVIAN LOCK (*Fig. 6*)

A variant type of snaphaunce lock was used in Scandinavia, where it had a life of some two hundred years from the mid-sixteenth to the mid-eighteenth centuries. In this lock the scear (A) passes horizontally through an aperture in the lock-plate to engage the tail of the cock (B). On the earlier examples the mainspring (C) is placed on the exterior of the lock-plate and presses down against the tail of the tumbler (F), subsequently during the second half of the seventeenth century, it was moved to the inside of the plate, as in the example illustrated. The pan-cover and steel are separate, the former being opened by hand before firing. There is no half-cock or safety device as the lock can be rendered safe by turning back the steel. On the later examples dating from the second half of the seventeenth century, the steel (E) is screwed to the pan-cover (D) in such a way that it can be turned to one side to provide a safety position. As with the English lock, the later forms of this lock have a tumbler cut with a notch, and the scear engages with this when set instead of with the tail of the cock. As the face of the steel could be turned away, there was no need for a safety position for the cock.

THE MEDITERRANEAN LOCK (*Figs. 7 and 8*)

As in the sixteenth-century snaphaunce, the scear operates horizontally through the lock-plate. There are two versions of this lock, the Italian (Roman) and the Spanish. Both were fully evolved by the first half of the seventeenth century. As the Italian form first appears in South Italy, it may have been an adaptation of the Spanish lock used by the Spanish rulers of the kingdom of Naples. In the Italian version, the scear consists of two arms (A) and (B), the front one of which engages the toe (C) of the cock to provide a half-cock position; while the rear one

engages the heel (D) of the cock to provide the full-cock position. When the trigger is pressed, both these arms are withdrawn horizontally through the lock-plate, thus allowing the cock to descend under the force of the mainspring (E). The latter is fixed to the exterior of the lock and presses down on the toe of the cock. There is no tumbler. The pan-cover and steel are made in one, hence the necessity for the half-cock position.

The Spanish lock (*Fig. 8*) differs from the Italian lock in that the two arms of the scear both pass through the lock-plate in front of the cock (A), the toe of which terminates in a blade (B). The half-cock arm is formed as a stud (C), the full-cock as a flat blade (D), and as the cock is raised the toe engages first with the stud and then with the plate. The mainspring (E) presses up against the heel of the cock. The pan-cover and steel are formed in one, but the latter has a deeply grooved face (F) which is detachable so that it may be easily renewed when worn. The mainsprings on the Spanish locks are often extremely strong, so that the steel probably had a shorter life than was the case with the French flint-lock.

THE FRENCH FLINT-LOCK (*Fig. 9*)

The main feature of the French lock, which was first introduced in the early seventeenth century, and became eventually the standard form in all North European countries, is the scear (A) operating vertically instead of horizontally. Two bents, half-cock (B) and full-cock (C), are cut in the tumbler (D), and the scear engages with them, instead of passing through the lock-plate to engage with the cock. Apart from the arrangement of the scear and the fact that the dog-catch is rarely used on the French lock, the latter corresponds in other respects to the English lock described above.

THE LORENZONI SYSTEM FLINT-LOCK REPEATING GUN (*Figs. 10–13*)

The action is operated as follows. The charges of powder and ball are carried in two tubular magazines in the butt (A and B), the openings of which are closed by a revolving breech block (C), turning at right angles to the axis of the barrel. In the breech block are cut two chambers (D and E) corresponding to the openings of the magazines. To load the piece, the breech block is revolved through half a turn by means of a lever on the left-hand side of the breech (*Fig. 10*); this motion brings these two chambers into line with the magazines, and allows a bullet and a charge of powder to drop into the chambers (the weapon being held muzzle downwards during this operation). The breech block is then revolved in the reverse direction, the bullet drops into the breech end of the barrel as the bullet chamber and barrel come into line (*Fig. 12*), and finally the powder chamber lines up with the barrel, forming a temporary breech (*Fig. 13*). Simultaneously the flash-pan (F) is primed with fine powder from a separate magazine (G) acting upon the same principle as the main magazine, whilst two cams (H and I) on the revolving breech block thrust back the cock into the 'half cock' position and close the pan-cover (*Fig. 11*).

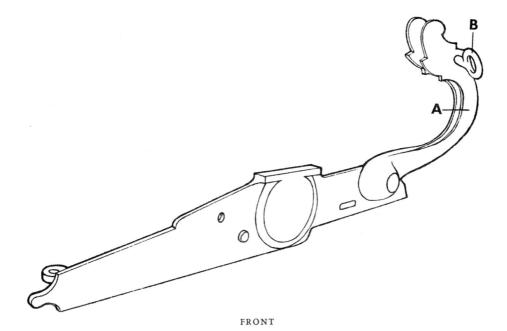

FRONT

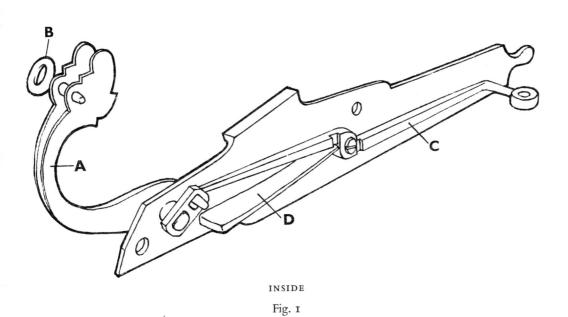

INSIDE

Fig. 1

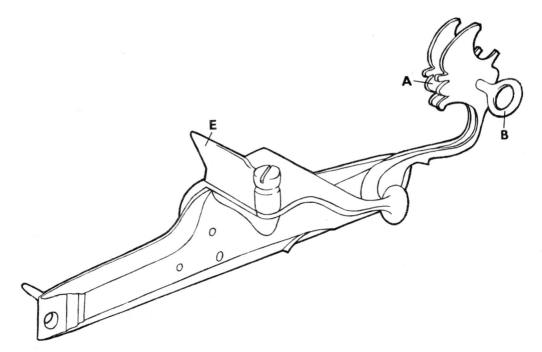

FRONT

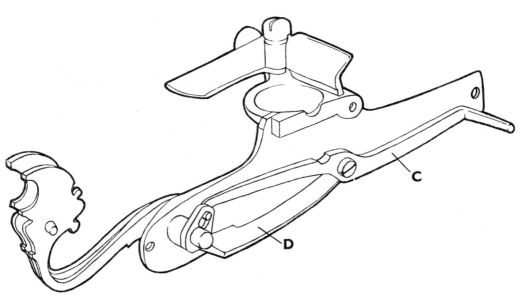

INSIDE

Fig. 2

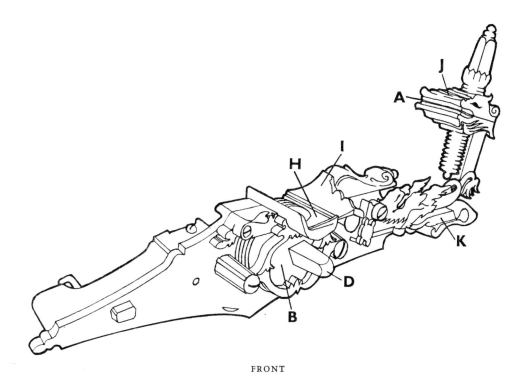

FRONT

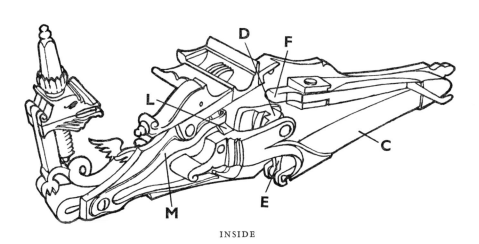

INSIDE

Fig. 3

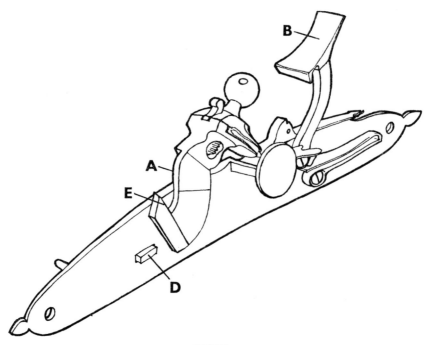

FRONT

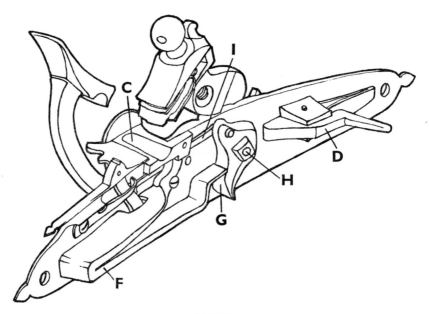

INSIDE

Fig. 4

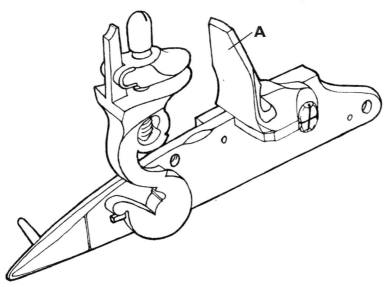

FRONT

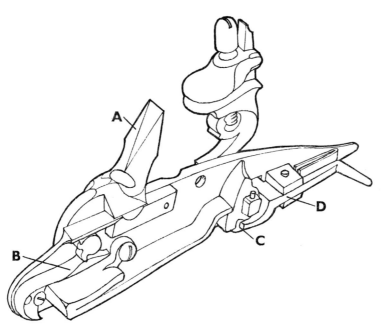

INSIDE

Fig. 5

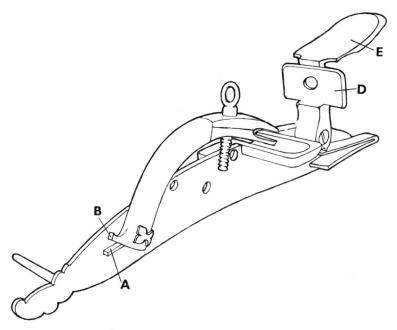

FRONT

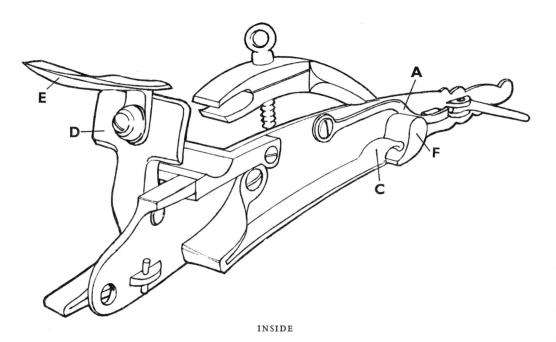

INSIDE

Fig. 6

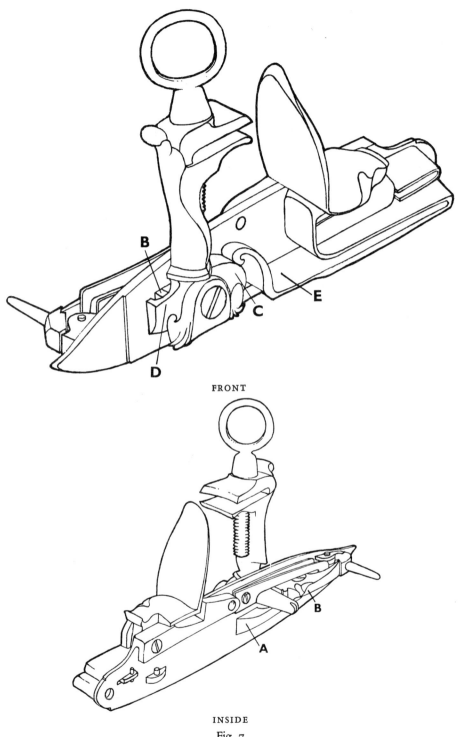

FRONT

INSIDE

Fig. 7

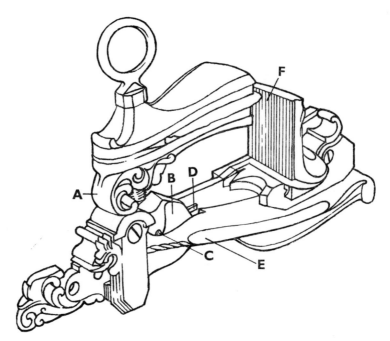

FRONT

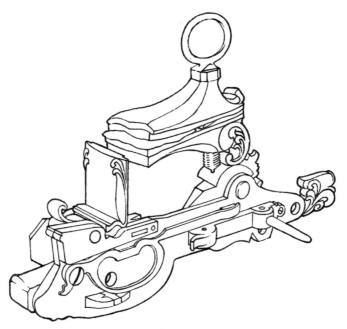

INSIDE

Fig. 8

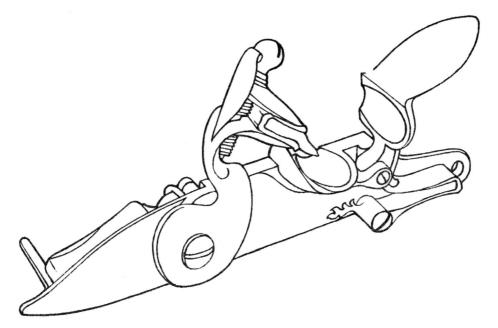

FRONT

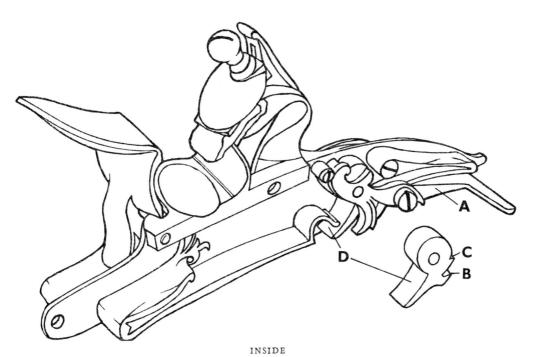

INSIDE

Fig. 9

35

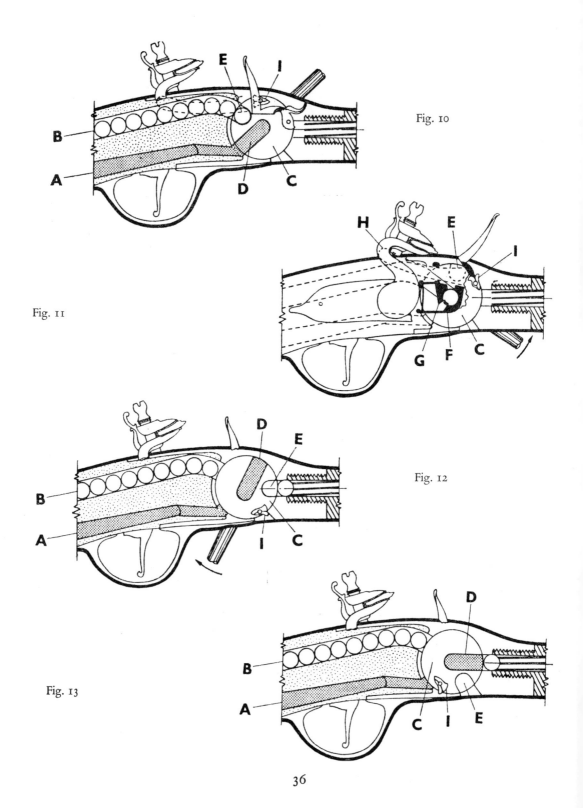

Fig. 10

Fig. 11

Fig. 12

Fig. 13

BIBLIOGRAPHY
OF WORKS CONTAINING INFORMATION ABOUT THE HISTORY OF FIREARMS

Extensive general bibliographies of works dealing with arms and armour are appended to Sir Guy Laking's *Record of European Armour and Arms* (5 vols., London, 1920-22) and to the *Catalogue* of European arms and armour in the Wallace Collection. In addition, a very full bibliography of works on firearms and related subjects has been published by Mr. Ray Riling under the title of *Guns and Shooting* (Greenberg, New York City, 1951), while new publications are listed regularly in the *Journal of the Arms and Armour Society*. The following bibliography is therefore intended only as a guide to further study.

BAXTER, D. R. *Superimposed Load Firearms, 1360–1860*. Hong Kong, 1966.

BLACKMORE, H. L. *British Military Firearms, 1650–1850*. London, 1961.

BLACKMORE, H. L. *Royal Sporting Guns at Windsor*. London, 1968.

BLAIR, C. *European and American Arms, c. 1100–1850*. London, 1962.

 Pistols of the World. London, 1968.

BOCCIA, L. *Nove Secoli di Armi da Caccia*. Florence, 1967.

BOEHEIM, W. *Meister der Waffenschmiedekunst, XIV–XVIII. Jahrhundert*. Berlin, 1897.

DUCHARTRE, P.-L. *Histoire des Armes de Chasse*. Paris, 1955.

GAIBI, A. *Le Armi da Fuoco Portatili Italiane dalle Origini al Risorgimento*. Milan, 1962.

 'Le Armi da Fuoco', *Storia di Brescia*, Vol. III, Brescia, 1964, pp. 817–84.

GELLI, J. *Gli Archibugiari Milanesi*. Milan, 1905.

GEORGE, J. N. *English Pistols and Revolvers*. Onslow County, North Carolina, 1938.

 English guns and rifles. Plantersville, 1947.

GRANCSAY, S. V. *Master French Gunsmiths' Designs of the Mid-Seventeenth Century*. New York, 1950.

HAYWARD, J. F. *The Art of the Gunmaker*. 2 vols. London, 1962–63. Second edition of Vol. I, 1965.

HELD, R. *The Age of Firearms*. New York, 1957.

HOFF, A. *Aeldre Dansk Bøssemageri især i 1600-tallet*. 2 vols. Copenhagen, 1951. Contains an English summary.

JACKSON, H. J. *European Hand Firearms of the Sixteenth, Seventeenth and Eighteenth Centuries . . . with a treatise on Scottish hand firearms by Charles E. Whitelaw*. London, 1923.

LAVIN, J. D. *A History of Spanish Firearms*. London, 1965.

LENK, T. *Flintlåset, dess uppkomst och utveckling*. Stockholm, 1939. English translation, *The Flintlock: its origin and development*, translated by G. A. Urquhart, edited by J. F. Hayward. London, 1965.

LINDSAY, M. *One Hundred Great Guns. An illustrated history of firearms*. New York, 1967.

NEAL, W. K. *Spanish Guns and Pistols*. London 1955.

NEAL, W. K. and BACK, D. H. L. *The Mantons: Gunmakers*. London, 1967.

PETERSON, H. L., (Editor). *The Encyclopedia of Firearms*. London and New York, 1964.

SCHEDELMANN, H. *Die Wiener Büchsenmacher und Büchsenschäfter*. Berlin, 1944.

STØCKEL, J. F. *Haandskydevaabens Bedømmelse*. 2 vols. Copenhagen, 1938–43. Reprinted 1964. The most comprehensive work on gunmakers and their marks.

STÖCKLEIN, H. *Meister des Eisenschnittes*. Esslingen a. N., 1922.

TERENZI, M. *L'Arte di Michele Battista Armaiolo Napoletano*. Rome, 1964.

THIERBACH, M. *Die geschichtliche Entwicklung der Handfeuerwaffen*. Dresden, 1886–87. *Nachträge*, 1899. Reprinted Graz, 1965.

THOMAS, B., GAMBER, O., and SCHEDELMANN, H. *Die schönsten Waffen und Rüstungen*. Munich, 1963. English translation, *Arms and Armour*. London, 1964.

ULLMAN, K. *Schmuck alter Büchsen und Gewehre. Jagdmotiv in der Büchsenmacherkunst (1650–1850)*. Hamburg and Berlin, 1964.

WINANT, L. *Firearms Curiosa*. New York, 1955. Reprinted London, 1961.

Early Percussion Firearms. New York, 1959. English edition, London, 1961.

LIST OF ILLUSTRATIONS

1. PLATE I. WHEEL-LOCK WITH SELF-SPANNING GEAR. *South German (Augsburg); about 1540–50.*

Farquharson Bequest. Length 9 ins.

M.701–1927

For convenience in spanning, the cock is placed in front of the wheel instead of in its usual position behind it. At the rear end is struck a maker's mark, a sickle with the inner edge of the blade serrated (Støckel No. 5847), attributed to the Augsburg gunmaker, Bartholomäus Markwart (died 1552) whose sons, Peter and Simon, were summoned to Spain to make wheel-locks for the Spanish court.

The lock is of early type with the cock-spring running round the wheel. This spring is carved with Renaissance leaf ornament: it is one of the earliest examples of mechanism by which the main-spring is spanned when the cock is drawn back.

Lit. A. Hoff: 'Hjullaase med seglformet Hanefjer', *Vaabenhist. Aarbøger*, III. Copenhagen, 1940, p. 68. J. Lavin: *Spanish Firearms*, London, 1964, p. 71 ff.

2. PLATE I. WHEEL-LOCK FOR A GUN. *German;* about 1600.

Length 12 in. M.402–1910

The lock-plate is engraved with two eagles with outstretched wings, enclosed with arabesques damascened in gold and silver against a blued ground. The cock is gilt. The elaborate ornamentation of this lock shows that no expense was spared on the finer firearms of the time.

3. PLATE I. WHEEL-LOCK FOR A PISTOL, ATTRIBUTED TO DANIEL SADELER. *South German (Munich);* about 1620–30.

From the Magniac Collection. Length 7 in.

124–1897

Chiselled, gilt and encrusted with gold, the cock formed as a dragon. A wheel-lock pistol in the Metropolitan Museum, New York, with stock entirely of iron has a very similar lock, the cock modelled as a dolphin. This latter pistol bears the arms of Maximilian, Elector of Bavaria, a dignity which he achieved in 1623. When acquired from the Magniac Collection this lock was mounted on the much later Michael Maucher rifle (No. 124–1897). It is now exhibited separately.

Lit. H. Stöcklein: *Meister des Eisenschnittes*, Esslingen 1922. *Bulletin of the Metropolitan Museum of Art*, New York, Vol. 27, 1932, pp. 16–18.

4. PLATE II. MATCH-LOCK PETRONEL. *French(?); second half of sixteenth century.*

Farquharson Bequest. Length 46 in.

M.485–1927

Walnut stock, profusely inlaid with hunting scenes and with monkeys and, on the inner side of the curved butt, with Hercules overcoming the Nemean lion. The ground is filled with foliate scrolls of engraved staghorn, some of the leaves stained green.

The barrel, of octagonal section throughout, has a brass V backsight and blade foresight. At the breech is stamped the barrel-smith's mark, a star within a shaped shield. The lock of conventional construction; there are traces of gilding on the plate.

These match-lock petronels were produced in quantity in Western Europe and in the absence of internal evidence, it is difficult to attribute one to a particular region. The barrels very often bear the mark of the Thuringian town of Suhl. Petronels of this type with strongly hooked butts are shown in the woodcuts of Jost Amman of Nürnberg and of his contemporaries. The tentative attribution to France is in this case based on the similarity of the inlay to that on French wheel-lock pistols of the same period.

5. PLATE II. WHEEL-LOCK PISTOL. *South German (Nürnberg); last quarter of sixteenth century.*

Farquharson Bequest. Length 16 in.

M.642–1927

The walnut stock is inlaid with stag-horn engraved with sea monsters and grotesque masks.

The butt-plate of brass is engraved with foliate scrolls and a coat of arms, but appears to be a later restoration. A belt-hook is attached to the stock on the opposite side to the lock; on the flattened end is a maker's mark, a hand with the letter W. (Støckel No. 5005). The same mark appears on the belt hook of a pistol in the Museum für deutsche Geschichte, Berlin, dated 1586.

The lock of usual construction with external safety catch. On the lock, the Nürnberg town mark and a locksmith's mark, an owl between the letters H F in a shaped shield.

The barrel which is swamped at the muzzle, bears the Nürnberg town mark and a barrel-smith's mark, partly obliterated.

The presence of a belt-hook indicates that this pistol was intended to be carried by a foot soldier. Sir Martin Frobisher is shown holding a similar wheel-lock pistol in his portrait by Cornelius Ketel in the Bodleian Library, Oxford. The portrait is dated 1577.

6. PLATE II. WHEEL-LOCK GUN. *German; dated* 1581.

Farquharson Bequest. Length 45 in.

M.615–1927

The walnut stock is inlaid with spiral scrolls of engraved stag-horn. In the butt are receptacles for three cartridges, to which access is obtained through a trap in the butt-plate. Double wheel-lock arranged for two consecutive discharges. Brass wheel-covers. Safety catch on each lock.

The barrel of octagonal section at the breech, the remainder round. It has two touch holes, one corresponding to each lock, providing for two charges, one loaded on top of the other. The barrel is roughly chiselled with a grotesque mask at the breech end, and with foliage at the midway point and at the muzzle. V back-sight and blade foresight. The barrel is dated 1581. Maker's mark stamped on each side of the breech, an anvil over the initials N.H. or (perhaps) H.N. over an indistinguishable device.

7. PLATE III. WHEEL-LOCK PISTOL. *German; dated* 1579.

Farquharson Bequest. Length 18 in.

M.628–1927

The stock entirely of iron. The butt has a flat oval termination, the hinged end opens to reveal a receptacle for cleaning materials. This cover is etched with the monogram I H supported by two lions rampant and surmounted by a coronet, with the date 1579. The lock with enclosed wheel and cock-spring on the interior of the plate. Safety-catch on the lock-plate. The barrel, octagonal at the breech, of circular section at the muzzle is struck with the initials L S and a star and the letter S within a shield.

The monogram is probably an abbreviated version of that of Julius, Duke of Brunswick-Lüneburg and Wolfenbüttel, reigned 1568–1589. The complete monogram consists of the initials I H Z S (*Jesus Hilf Zu Seligkeit*). The full monogram is on the butt-trap cover of a somewhat similar pistol, but with brass stock, in the Tower of London Armouries (No. XII. 1076).

8. PLATE III. DESIGN FOR A PAIR OF WHEEL-LOCK PISTOLS in etched outline and wash. *South German; late sixteenth century.*

1545

Though the designs are evidently intended for a pair of pistols, there are slight differences between the ornament of the two, mainly as regards the triggers, trigger-guards and pommels. The stocks were intended to be inlaid in engraved stag-horn, the pommels would probably have been of cast, chiselled and gilt bronze. The barrels and locks would probably have been of blued steel, chiselled against a gilt ground. The hunting scenes on the stock of the upper pistol are similar to but not identical with those in the *Venationes* of Jan van der Straet (1530–1605), usually known as Stradanus. The 'Grotesques' on the barrels seem to be derived from the engraved ornament of Etienne Delaune (1519–c. 1588). The design and ornament of the lock is very similar to that of Daniel Sadeler of Munich and only amongst the works of the Munich school would it be possible to find existing firearms of comparable magnificence. The iron strap inset on the left-hand side of the stock opposite the lock carries a safety catch. There is another copy of this print in the Bodleian Library, Oxford.

Lit. J. F. Hayward, 'A German design for a pair of wheel-lock pistols'. *Connoisseur*, Vol. CXXIII, pp. 16–18.

9. PLATE IV. WHEEL-LOCK PISTOL. *South German; dated* 1579.

From the De Cosson Coll., Christie's. May 2–3, 1893. Length 21 in. 612–1893

The stock is inlaid with closely set spiral foliate scrolls of stag-horn enclosing grotesque masks, birds and monkeys in engraved stag-horn.

The stock bears the stockmaker's signature, the initials B. H. (Støckel 2043) and the date (15)79. Large ball butt.

The lock, with exterior safety catch, is unmarked.

The barrel is lightly chiselled with grotesque masks and foliage. It bears the barrel-smith's initials and also his mark, a chamois head between the letters S R with the figures 73 in a shaped shield (Støckel 4524 and 4525). The figures should probably be read as 1573, and perhaps record the date of registration of the mark. On the barrel, the date 1579.

The pair to this pistol is preserved in the Musée de l'Armée, Paris (No. M.1606 in the Catalogue of 1889). There are two powder flasks in the Museum decorated *en suite* with this pistol, though not acquired at the same time. One is circular with mounts of gilt bronze (M.143–1923), the other of trefoil outline (67–1903). This pistol belongs to a large group of similarly decorated pieces; there are numbers in the Dresden Rüstkammer (see Haenel, *Kostbare Waffen aus der Dresdner Rüstkammer*: Tafel 74), and they are sometimes described as Saxon. They conform to the South German fashion of the last quarter of the sixteenth century.

10. PLATE IV. PAIR OF WHEEL-LOCK PISTOLS. *South German (Augsburg); last quarter of sixteenth century.*

Farquharson Bequest. Length 19¼ in. M.489, 489a–1927

The wood stocks overlaid with marquetry of cow-horn and stag-horn, engraved with scenes from the chase, monsters and grotesque masks.

On the pommels, lion's mask medallions. The ornament is similar on each pistol.

The lock-plates bright, originally blued, the wheel cover and springs gilt. Trigger guard and trigger gilt.

The barrels blued and gilt, chiselled with two bands of conventional foliage, and, at the breech, a grotesque mask. On the barrels, the Augsburg town mark and barrel-smith's mark of Jäger, a hunting horn (Støckel 5223).

This is the standard type of pistol for mounted troops of the latter years of the sixteenth century. The German city arsenals used to contain them in large numbers, as does the Zeughaus of Graz in Styria still. They were carried in holsters at the saddle bow, and contemporary woodcuts show mounted men with as many as four of them. e.g. Jost Amman. *Kunstbüchlein*, fol. T iii.

11. PLATE IV. WHEEL-LOCK PISTOL. *South German (Nürnberg); dated* 1593.

Joicey Bequest. Length 21 in. M.230–1919

The walnut stock is inlaid with hunting subjects amidst foliate scrollwork in engraved and partly stained stag-horn, and with plaques engraved with figures in contemporary costume in the manner of woodcuts by Jost Amman. Large ball butt.

The lock of French type with mainspring fixed separately in stock is stamped with the maker's mark, a spur (Støckel 5882). It is dated 1593 on the priming pan. Barrel of round section, the muzzle slightly swamped, stamped with the same spur mark as the barrel and with the Nürnberg town mark.

This pistol is exceptional in that, though of Nürnberg manufacture, it is equipped with the typical French wheel-lock with independently attached mainspring. As a rule only French wheel-locks have this type of construction.

12–15. PLATE V. FOUR DESIGNS FOR ENGRAVED ORNAMENT ON WHEEL-LOCK RIFLE BUTT-PLATES, drawn with pen and ink and washed with colour. *German; end of the sixteenth century.*

Purchased from the funds of the Murray Bequest. E.1990–1993–1914

The designs belong to a series of sixty drawings,

all from the same workshop; they correspond to the engraved ornament found on South German stocks of the end of the sixteenth and early seventeenth centuries. They are adapted from engravings or woodcuts by Virgil Solis, Jost Amman and, probably, Paul Flindt. The monogram of Virgil Solis on Nos. 10 and 11 is a spurious addition. The subjects are as follows:

12. Adapted with slight alterations from the figure of a horseman on sheet T ii (obverse) of Jost Amman's *Kunstbüchlein*, published Frankfurt am Main 1599.

13. The figures of the huntsman and the dog in the right foreground are adapted from Jost Amman's *Künstliche Wohlgerissene Figuren von allerlei Jagd- und Waidwerk*, Frankfurt a. Main, 1592, from the section headed *Wie ein Jäger den Hirsch aufsuchen und behunden sol*. The figure of the fallen stag with the hound on the left is apparently from another woodcut in this same work.

14. Diana with her nymphs surprised by Actæon; in the background, Actæon, changed into a stag, torn to pieces by his hounds.

15. Venus lamenting over the wounded Adonis. Copied with slight modification from Virgil Solis's engraving of this subject in his illustrations to Ovid's Metamorphoses.

The whole series of designs is discussed and catalogued in *Livrustkammaren*, Stockholm. Vol. V, 7, pp. 109–34. J. F. Hayward, 'Designs for ornament on gunstocks'.

16. PLATES VI, VII. WHEEL-LOCK RIFLE. *East German; about 1600.*

From the Shandon Collection. Length 54¼ in.
802–1877

Walnut stock inlaid with strapwork and figures in engraved stag-horn; on the cheek-piece an oval medallion engraved with Pyramus and Thisbe surrounded by strapwork with cherubs and warriors. On the patch-box cover is the figure of an officer of pikemen in early 17th century costume. The fore-stock is inlaid with animals and figures amidst strapwork. The lock is engraved with Orpheus charming wild animals, the dog-head with a monster.

Blued octagonal barrel, rifled with eight grooves, V backsight and blade foresight, in-

cised at the breech H K (Støckel No. 2937 or 2944) and stamped underneath I.B.

A detached wheel-lock in the Museum (M.535–1924) is engraved in a similar style and signed with the monogram H L linked. No. A1095 in the Wallace Collection appears to come from the same workshop. Dr. A. Hoff has studied this group and attributes them to a workshop in Poland or Lithuania, see *Livrustkammaren*, Vol. IX, p. 205. 'En Polsk-Litauisk Hjullåstype'.

17. PLATES VI, VII. WHEEL-LOCK RIFLE. *German; dated 1605.*

From the Bernal Collection. Sale Catalogue. Lot No. 2639. Length 45½ in.
2240–1855

The walnut stock is inlaid with compositions of strapwork in engraved stag-horn. On the cheekpiece an escutcheon with the arms of Hatstein and the date 1605, within a ring inscribed *Marquardus von Hatstein zu Weilbach*. On a panel behind the barrel tang are engraved the initials of the stockmaker, H E.

Lock with domed covered wheel. To the lock-plate is attached a brass plate, formerly gilt, in the form of a sea-horse.

Octagonal barrel with V-backsight and blade foresight, rifled with eight grooves. At the breech, the barrel-smith's mark, the initials O S over a toothed wheel in a shaped shield (Støckel 4206).

Weilbach is a small village to the east of Mainz on the north bank of the river Main.

18. PLATES VI, VII. WHEEL-LOCK RIFLE. *Saxon (Dresden); dated 1606.*

From the Bernal Collection, Sale Catalogue No. 2649. Length 48 in.
2241–1855

The stock is inlaid with engraved staghorn panels within strapwork and with iron plaques, formerly blued, to which are applied pierced gilt bronze panels. On the butt-trap cover are the initials F.F., presumably of the engraver. Iron heel-plate, to which is applied a gilt bronze plaque of a lady on horseback after a woodcut by Jost Amman. Lock of bright steel, formerly blued, to which are applied gilt bronze masks and a panel of strapwork surmounted by a

female term. The working parts of the lock are each numbered 10.

The octagonal barrel, rifled with eight grooves, formerly blued but now bright bears the initials of G.G. of Georg Geissler (Støckel No. 434) and the date 1606. Underneath is stamped a cross. The breech end has a brass housing.

Back and foresights surmounted by cast and gilt scrollwork. Georg Geissler (or Gessler), born in Strasbourg, was admitted to citizenship of Dresden on 14th November, 1607. He was subsequently appointed *Kurfürstlicher Sächsische Büchsenmeister*.

Lit. W. Holzhausen: *Zeitschrift für Hist. Waffenkunde*, Vol. XIV, p. 190.

19. PLATES VIII, IX. PAIR OF WHEEL-LOCK HOLSTER PISTOLS. *German; about 1600–10.*

J. G. Joicey Bequest. Length 30 in.

M.232, 232a–1919

The walnut stocks are profusely inlaid with oval plaques engraved with allegorical figures within elaborate scroll-work enclosing minute human figures, animals and birds, of stag-horn and ivory. The inlaid ornament appears to be derived from engraved designs by Theodor de Bry or Adriaen Collaert. The locks, of early seventeenth-century type, are unsigned. Octagonal barrels, the blueing renewed. Stamped at the breech, a barrel-smith's mark, partly obliterated through cleaning.

There is no feature in the mechanism or ornament which would justify an attribution to any particular locality within the German cultural area.

20. PLATES VIII, IX. WHEEL-LOCK PISTOL. *South German (Nürnberg?); first quarter of seventeenth century.*

Murray Bequest. Length 30½ in. M.1082–1910

The ebony stock is inlaid with figures in contemporary costume, amorous subjects and scenes of the chase executed in engraved mother of pearl and engraved and stained stag-horn. In the face of the stock opposite to the lock is inlaid a scene of a lady and three gentlemen at an *al fresco* meal accompanied by two minstrels.

The engraving on the inlay work is of exceptionally fine quality. The lock, of early seventeenth-century type, has a finely chiselled pyrites holder in the form of a monster's head. The wheel-guide is formed as a dragon.

The barrel is damascened in gold and silver with panels of arabesques. The bore measures only 9 mm.

This pistol is one of a group of wheel-lock firearms all stocked in similar manner: in ebony inlaid with mother of pearl, stag-horn and ivory, stained green. Examples are to be seen in the Wallace Collection (Nos. A.1152/3) in the Musée de l'Armée (Nos. M.1648 and M.1650). Many bear the Nürnberg town mark on the lock or barrel.

Lit. J. F. Hayward: *The Art of the Gunmaker* (2nd ed.). Vol. I, London, 1965, p. 175.

21. PLATES VIII, IX. WHEEL-LOCK PISTOL. *Northern France; about 1610–20.*

Farquharson Bequest. Length 31½ in.

M.488–1927

The walnut stock profusely inlaid with mother of pearl, stag-horn and brass wire scrolls. The mother of pearl and stag-horn plaques are roughly engraved with birds, animals and foliage. The ground between the plaques is set with silver studs and minute six-pointed stars in brass. Steel mounts, brass ramrod pipe.

Lock of French construction: on the lockplate a maker's mark IP over a star in a shaped shield.

At the breech the barrel is ribbed: it was formerly gilt also. It is of small bore (10 mm).

Compare the similar pistol in the Wallace Collection, No. A.1179, where reference to other similar pieces is made. A number of pistols with stocks of this type are preserved in the Livrustkammaren, Stockholm. They are found with both the French and the German construction of wheel-lock.

22. PLATE X. WHEEL-LOCK PISTOL. *South German (Nürnberg?); about 1570–80.*

Farquharson Bequest. Length 29½ in.

M.631–1927

The stock entirely of iron, the lock stamped with a maker's mark, a lion rampant beneath

the initials HS within a shaped shield. The dog engraved with a monster's head. The barrel divided into two sections, that at the breech fluted.

The stocks of this type of pistol were usually etched with hunting subjects and foliate scroll-work, but there is no trace of such decoration on this example. The section of the butt behind the pommel was originally bound with cord to give a better grip, but this is now missing. A similar pistol entirely etched and gilt, is in the Wallace Collection, No. A.1167.

23. Plate X. wheel-lock breech-loading holster pistol. *German; early 17th century.*

Farquharson Bequest. Length 27¾ in.

M.641–1927

Walnut stock, slightly inlaid with engraved horn, fish-tail butt, the pommel with iron ring. Conventional wheel-lock with external wheel, the octagonal barrel is stamped H S at the breech. The breech is hinged laterally, being secured by a spring catch at the rear end. Loading is performed by inserting a separate iron cartridge, now missing. This was one of the most popular breech-loading systems from the sixteenth to the nineteenth century. The earliest known example is on a gun from the armoury of Henry VIII in the Tower of London (Cl. XII.1).

24. Plate X. wheel-lock holster pistol. *French, second quarter of 17th century.*

From the Cabinet d'Armes of Louis XIII, King of France. Transferred from the Rotunda Museum, Woolwich. Length 25 in. M.7–1949

Walnut stock, the faceted ovoid pommel stained black. Wheel-lock of French construction with main-spring fixed in stock. Instead of having the axle of the mainspring projecting, the external wheel is recessed to take the end of the key. Octagonal barrel.

Stamped on the stock in front of the trigger-guard is the number 215 of the Inventory of Louis XIII's *Cabinet d'Armes.* The corresponding entry reads: 'Une autre paire de pistolets à roüet, de 23 pouces, le canon à huit pams, tout uny, le roüet de mesme, montée sur

un bois rouge, tout uny, le pommeau de bois noircy a huits pams'.

Lit. J. F. Hayward: *The Art of the Gun-maker* (2nd ed.), Vol. I, 1965, pp. 142–4.

25 and 26. Plate XI. two designs for engraved ornament on wheel-lock musket butt-plates, drawn with pen and ink, and washed with colour.

German end of the sixteenth century. Purchased from the funds of the Murray Bequest.

E.2002, 2003–1929

These designs of strapwork enclosing human figures and animals recall the engraved ornament of the Nürnberg artist, Paul Flindt, who published a number of books of designs in Vienna between 1592 and 1618. See also notes above on Nos. 12–15 which belong to the same series.

27. Plate XI. wheel-lock. *French; late sixteenth century.*

Stovell Bequest. Length 8½ in. M.176–1928

The elements of this lock are finely chiselled with moulded and roped borders, the dog-head and rear finial of the plate with monster's heads. The wheel-cover and cock-spring are secured by bolts held in place by pins on the interior of the plate instead of screws.

28. Plate XI. wheel-lock. *French (Nancy); first quarter of seventeenth century.*

Farquharson Bequest. Length 9 in.

M.698–1927

The wheel-cover of gilt brass, pierced with interlacing strapwork, now defective, the tail of the plate encrusted with a trophy of arms and floral ornament in gold and silver against a blackened ground. Signed between the pan and the cock *Habert*-Haber (or Habert) is recorded in Nancy about 1625. The lock is of German construction with the mainspring attached to the plate. The proximity of the German frontier presumably accounts for the lock construction.

29. Plate XI. wheel-lock. *North Italian (Brescia); mid-seventeenth century.*

Farquharson Bequest. Length 7⅛ in.

M.496–1927

The lock-plate overlaid with interlacing olive branches in chiselled steel.

30. PLATE XII. WHEEL-LOCK GUN. *French; beginning of seventeenth century.*

From the Cabinet d'Armes *of Louis XIII*. Transferred from the Rotunda Museum, Woolwich. Length 72 in. M.12–1949

The half-length stock is of pear wood, mounts of iron. The lock of French construction finely chiselled, the pyrites holder in the form of a dragon, the rear part of the lock-plate in the form of a boar's head.

The barrel Turkish, of round section at the breech, the remainder polygonal. The point of junction of the two sections is marked by a panel of conventional foliage chiselled in the thickness of the barrel. The muzzle of tulip shape is set with two rings of silver. Aperture rear-right, blade foresight.

The ramrod, entirely of wood, fits loosely in its slot and is probably a restoration.

This is one of the firearms brought to England from Paris as trophies of war after the battle of Waterloo. Stamped in the top of the stock, immediately behind the barrel, is a segment of a circle, probably part of the number 3 of the Inventory of the *Cabinet d'Armes* of Louis XIII, King of France. The corresponding entry in the Inventory is 'Trente quatre arquebuses touttes simples, de 6 pieds de long ou environ'. Though the Inventory number is not clearly visible on the stock, this gun is typical of the firearms of Louis XIII, particularly as regards the stocking. In view of its provenance, the Paris Arsenal, there appears to be no reason to doubt its attribution to the personal collection of Louis XIII.

31. PLATE XII. WHEEL-LOCK DOUBLE-BARRELLED PISTOL. *French; about 1600.*

From the Cabinet d'Armes *of Louis XIII*. *A.W. Hearn Bequest*. Length 18¾ in. M.13–1923

The stock is inlaid with foliate scrollwork and trophies of arms executed in brass wire, and set with pewter studs. The oviform pommel of wood divided into panels by strips of horn and of brass, the latter chased with running foliage, set alternately. The intervening panels inlaid with brass wire and pewter studs. The trigger-guard of iron, etched, with traces of gilding. The fore-end of brass chased with trophies of arms.

The locks of German construction, the plates etched with arabesques and gilt; the moving parts blued. There is only one trigger which actuates both locks simultaneously.

The two barrels are set side by side. They are etched and gilt with interlacing strapwork forming panels enclosing trophies of arms and roses set alternately. There is no maker's mark.

There is no trace of an inventory number on the stock of this pistol, but it corresponds exactly with the No. 237 of the *Cabinet d'Armes* of Louis XIII, King of France. The description of this, and of the preceding piece are as follows:

236. 'Un pistolet à deux canons et deux roüets . . . les canons touts ronds et tout gravez de trophées et de roses dans des compartimens, la platine couleur d'eau montée sur un bois de poirier enrichy et tout remply de fillets de cuivre et de d'estain'.

237. 'Un autre pistolet, aussy a deux roüets tout pareil au précédent, excepté que les cannons sont dorez et qu'il n'a que 18 pouces de long.'

The absence of the Inventory number can probably be explained by the fact that the stock is completely covered with inlay work which would have been damaged if a number were stamped into it.

32. PLATE XII. WHEEL-LOCK FOWLING-PIECE FOR A YOUTH. *French; about 1620–30.*

From the Cabinet d'Armes *of Louis XIII, King of France*. Length 48 in. 603–1864

The pearwood stock is slightly carved, iron mounts. Lock of French type with detached mainspring. The barrel octagonal at the breech, the remainder round. V-backsight, stud foresight.

This gun is stamped on the underside of the stock in front of the trigger-guard with the number 5 of the Inventory of the *Cabinet d'Armes*. The corresponding entry in the Inventory reads 'Quarante trois arquebuses toutes

45

simples, de 3 pieds ou environ'. In view of the extreme lightness and small size of this piece, it would appear to have been made for Louis XIII when a boy. It is not known how it reached England. It may have been taken as a trophy from the Paris Arsenal by an officer in the British Army of Occupation in 1815. Two other firearms bearing the same Inventory number are in the Musée de l'Armée, Paris (Nos. M.101, M.103); another is in the Collection Pauilhac, now in the same Museum.

33. PLATE XIII. WHEEL-LOCK RIFLE (TSCHINKE). *Silesian (Teschen); mid seventeenth century.*

From the Bernal Collection, No. 2339. Length 45 in. 2217–1855

Walnut stock inlaid with engraved stag-horn and mother of pearl. On the cheek-piece an escutcheon with the arms of a Prince of Liechtenstein, probably Karl Eusebius (1611–1684). The lock with external mainspring decorated with punched work, originally blued and gilt. Octagonal barrel rifled with eight grooves and decorated with three gilt panels of punched foliage. The backsight enclosed within a tube. These light wheel-lock rifles were used for shooting at sitting birds. They were produced in large numbers in the seventeenth century by a group of masters working in the town of Teschen on the borders of Poland and Czecho-Slovakia. They are represented—often in large numbers—in the German hereditary armouries. The same type of rather coarse horn and mother-of-pearl inlay is found on wheel-lock rifles and flint-lock pistols made in the same locality. Other Teschen-made firearms in the Museum include another Tschinke, signed H.K. (2218-1855), a wheel-lock rifle, signed G M K (M.101–1930) and a powder-flask (2246-1855).

Lit. V. Karger: 'Neue Teschner Beiträge zur Herkunftsfrage der Teschinken', *Zeitschrift für historische Waffen und Kostumkunde,* 1964, p. 29.

34. PLATE XIII. WHEEL-LOCK RIFLE. *South German; Regensburg about 1600.*

Length 32½ in. M.48–1953

The walnut stock overlaid with carved ebony, enclosing panels of carved stag-horn, is attributed to Peter Opel of Regensburg. The whole surface is carved with interlacing strapwork interspersed with bunches of fruit and animals derived from Flemish sixteenth-century pattern books of engraved ornament, or perhaps from Jost Amman's engravings in the Flemish manner. The stag-horn plaques, which are executed with exceptional fineness, are carved with hunting subjects and with half- and full-length figures of Turks, including a standard bearer (on buttplate), musketeers (on underside of stock), bowmen, etc. The Turkish subjects, which reflect the endemic wars against the Turks in Eastern Europe, are probably derived from the engravings of the Nürnberg artist, Jost Amman, in particular from the series of Turkish figures in his *Kunstbüchlein*.

The lock, of normal German construction, is engraved over the whole of its exterior surface with figures emblematic of abundance amidst foliate scrolls. The ring securing the wheel to the lock-plate and other details of the lock, the trigger and the trigger guard are gilt. A maker's mark on the lockplate is indecipherable. The octagonal barrel is engraved over its whole surface with foliate scrolls enclosing eight oval panels with emblematic female figures from muzzle to breech as follows:

1. Temperance	2. Faith	3. Fortitude
4. Truth	5. Justice	6. Charity
7. Humility	8. Prayer	

From the collection of Prince Fugger at Schloss Babenhausen, between Augsburg and Ulm, formerly exhibited in the Fugger Museum at Augsburg (No. 1044).

This gun is of unusually small proportions and may have been constructed for a young man or for a lady. The quality of the ornament of this gun is so high that there seems no reason to doubt that it was made for a member of the Fugger family. The ebony veneer is composed of a large number of small fragments pieced together; this method has presumably been adopted in order to achieve uniformity in the colour of the wood, as ebony in larger pieces has lighter streaks.

A wheel-lock rifle in the Kunsthistorisches

Museum, Vienna (No. D.213), the stock of which appears to be carved by the same hand, is signed by Peter Opel.

Lit. J. F. Hayward: *The Art of the Gunmaker* (2nd ed.), Vol. I, plate 43b.

35. PLATES XIII, XVI. WHEEL-LOCK RIFLE. *South German (Schwäbisch-Gmünd); about 1670–80.*

From the Magniac Collection, Christie's, 4 July 1892. Lot 734. Length 43½ in. 124–1897

The pearwood stock carved and inlaid with panels of carved ivory. On the cheek-piece, an ivory plaque of Diana and Actæon, carved in high relief, on the butt-trap cover, a composition of a female figure holding in her hands a sail (Fortuna?) supported on the back of an eagle, which holds in its claws, a crown, a covered cup, a trumpet and a purse (symbolic of worldly power?) Above, a figure of cupid in flight, below three cherubs. The butt and fore part of the stock are inlaid with panels running longitudinally, carved with scenes of the chase, including figures in costume of the third quarter of the seventeenth century. The stock is signed behind the tang of the barrel *M. M.* in monogram for Johann Michael Maucher of Schwäbisch-Gmünd.

The lock, though contemporary, is not the original. It is ornamented with finely pierced and engraved panels of flowers and foliage in brass. The inside of the plate is stamped with a maker's mark, perhaps a female figure.

The octagonal barrel is inlaid with gold with a design of lozenges at the breech. The upper plane at the breech is pierced with a vertical hole for breech loading. The hole is filled with a screw plug in which is cut a slot which serves as back-sight and at the same time gives purchase for a tool to unscrew it. The barrel is rifled with eight grooves.

J. M. Maucher was born on 16 August 1645 as sixth son of the Österskirch gunmaker, Georg Maucher. He worked at first in Schwäbisch-Gmünd, but moved subsequently to Würzburg, probably about 1690. He was received as a citizen of Würzburg in 1696. He is repre-sented by a series of six wheel-lock rifles in the Bayerisches National Museum, Munich, of which the earliest is dated 1670 and is signed as having been made in Schwäbisch-Gmünd. The latest, which was made in Würzburg, is dated 1693. These firearms are decorated in a similar manner to No. 50, and are described in detail by W. Boeheim, *Meister der Waffenschmiede-kunst*, pp. 129–30.

Lit. M. v. Ehrental: *Waffensammlung d. Fürsten Salm-Reifferscheidt.* No. 187, Plate III; S. V. Grancsay: 'Carved gunstocks by Johann Michael Maucher'. *Journal of the Walters Art Gallery*, 1939; ibid. 'Enriched Historical Arms' Bulletin Metropolitan Museum of Art, New York, December, 1948; E. Petrasch: 'Über einige Jagdwaffen mit Elfenbein-schnitzerei', *Zeitschrift für Hist. Waffenkunde*, 1960, p. 11.

36. PLATES XIV, XV. WHEEL-LOCK PISTOL. *Spanish (Ripoll); dated 1614.*

From the Brett Collection, illustrated in the catalogue, plate C, No. 4. *Farquharson Bequest.* Length 22 in. M.487–1927

Walnut stock overlaid with a casing of iron, the latter chased with Renaissance ornament interspersed with Mauresques, and pierced with rectangular panels through which the wood stock can be seen. These panels are also carved with Mauresques. The lock-plate and barrel are decorated en suite. The borders of the lock-plate etched with interlacing ornament. The belt hook is missing. The barrel, octagonal at the breech, round at the muzzle has a vertical slot back-sight. There is no fore-sight.

This is one of the very few wheel-locks of Ripoll make to survive and is the earliest dated example. An almost identical one in the Museo Correr, Venice, is inscribed 'P.L.S. Ercole Tascha di Venecia' and was presumably made for a Venetian customer.

Lit. C. Buttin: 'L'Arquebuserie de Ripoll', *Armes à feu et armes blanches*, 1914. T. T. Hoopes: 'Ripollsche Radschlosspistolen'. *Zeitschrift für Hist. Waffenkunde.* N.F. IV pp. 226–9. J. Lavin: *Spanish Firearms*, London, 1964, p. 218 ff. C. Blair: *Pistols of the World*, London, 1968, pls. 83–4.

37. PLATE XIV. PAIR OF WHEEL-LOCK PISTOLS. *Swiss (Zürich); second quarter of the seventeenth century.*

Ramsbottom Bequest. Length 24 in.

M.2798, 2798a-1931

The surface of the butts is lightly incised with floral ornament, now much rubbed. The barrels and mounts of gilt brass.

The lock-plate, of gilt brass, is finely engraved with floral scrolls, probably derived from the engraved designs of Michel le Blon. The lock is secured by three screws.

The barrel of octagonal section at the breech is finely engraved with flower compositions, probably derived from the *Schweiff-Büchlein* of G. Krammer of Zürich.

These pistols belong to a group of similar firearms, both flint-lock and wheel-lock, all with mounts of gilt and engraved brass. The group includes a wheel-lock pistol in the Metropolitan Museum, New York (illustrated and described in the *Bulletin of the Metropolitan Museum of Art*, Vol. V, p. 148) signed 'Felix Werder fecit in Zürich 1630', a pair of wheel-lock pistols in the Windsor Castle Armoury Cat. No. 361 (ill. Laking, *Armoury of Windsor Castle*, Plate 22), a wheel-lock pistol in the Stuyvesant Collection, U.S.A. Cat. No. 193 (ill. Bashford Dean: *The Stuyvesant Collection*, Plate XLVII), signed 'Felix Weerder fecit Tiguri Anno 1640', a wheel-lock pistol from the *Cabinet d'Armes* of Louis XIII in the Keith Neal Collection, Warminster and a garniture of a flint-lock gun and a pair of pistols in the Vienna Waffensammlung, and the Schweizerisches Landesmuseum, Zürich, respectively, signed 'Felix Werder Tiguri Inventor 1652' (ill. T. Lenk, *Flintlåset*, Plate 32, 2, 3). Though unsigned, the pair here described can be attributed to Felix Werder also.

Lit. E. A. Gessler, 'Der Gold und Buchsenschmied Felix Werder von Zürich 1591-1673'. *Anzeiger für Schweiz. Geschichte und Altertum,* 1922, p. 113.

38. PLATE XIV, XV. PAIR OF WHEEL-LOCK PISTOLS. *German (Rhineland); about 1620-30.*

Given from the Collection of Col. G. Stovell.
Length 22¾ in. M.175, 175a-1928

Walnut stocks inlaid with engraved silver plaques and silver wire scroll-work. The butt caps, fore-end and ramrod pipes of nielloed silver. The ornament on the butt caps, consisting of a blank heraldic escutcheon surrounded by foliate scrollwork enclosing trophies of arms and figures of cherubs appears to be derived from the engraved designs of Johann Theodor de Bry. The ornament inlaid in the stock on the side opposite the lock-plate, a parrot perched on a bunch of fruit, is copied from a book of engraved ornament published by Michel le Blon in Frankfurt a. Main in 1611. The relevant sheet is reproduced by T. Lenk, *Flintlåset*, Plate 107, 3.

The locks are engraved with foliage, and show traces of gilding.

Octagonal barrels, lightly engraved with foliage; at the muzzles a chiselled moulding, originally gilt.

These pistols belong to a group, all stocked in a similar way, dating from the first half of the seventeenth century. They include the wheel-lock fowling piece signed 'Jean Henequin à Metz 1621' in the Bayerisches National Museum, Munich (ill. *Flintlåset*, Plate 104), the wheel-lock pistol signed by Matteus Nutten of Aachen in the National Museum Copenhagen (ill. *Flintlåset*, Plate 105, 3), a wheel-lock carbine in the Tower of London, No. XII, 1551, and another carbine in the castle of Skokloster, No. 188. With the possible exception of the fowling-piece in Munich, all these firearms, including the pistols here described, seem to have been stocked by the same master.

39. PLATE XV. WHEEL-LOCK WITH TWIN COCKS. *Italian; mid-seventeenth century.*

Farquharson Bequest. Length 14¼ in.

M.494-1927

The plate incised with conventional foliage and gilt against a punched blued ground. External wheel with chiselled wheel-guide. The provision of a reserve dog was a usual feature on Italian wheel-locks. The place of origin of these locks with ornament chiselled in very high relief is unknown. See also No. 46 (Plate XIX).

40. PLATE XVII. GUN. *French; about* 1620–30, but with Italian snaphaunce lock.

From the Cabinet d'Armes *of Louis XIII, King of France.* Transferred from the Rotunda Museum, Woolwich. Length 77½ in.

M.4–1949

The stock of pearwood (?), the butt club-shaped with sliding patch-box cover. The breech end of the barrel is octagonal, the remainder is sixteen sided. Stamped on the underside of the stock in front of the trigger-guard is the inventory number 138 of the Louis XIII *Cabinet d'Armes*. The corresponding entry in the Inventory reads 'Dix huit fusils françois tout simples et communs, depuis 5 jusqu'à 6 pieds de long ou environ'.

The lock is of most unusual construction and is closely modelled on the type of wheel-lock manufactured in Brescia in the early seventeenth century. The lock-plate, the cock-head, pancover and steel-spring are all of Brescian form. The scear is of standard wheel-lock form: it ends in an arm which passes horizontally through a hole cut in the plate and engages in a recess cut on the inside of the base of the cock. Half-cock is obtained by a manually operated catch on the big exterior of the lock which engages in a recess cut in the side of the cock, full cock by the sear engaging in the hole on the inside of the cock. The tumbler and main-spring are of conventional form.

Lit. T. Lenk. *Flintlåset.*

41. PLATE XVII. GUN. *French; second quarter of seventeenth century* (the lock perhaps Italian).

From the Cabinet d'Armes *of Louis XIII, King of France.* Transferred from the Rotunda Museum, Woolwich. Length 77½ in.

M.5–1949

The stock of pearwood (?), the butt club-shaped with sliding patch-box cover. The barrel octagonal at the breech end, the remainder round. Stamped on the underside of the stock in front of the trigger guard is the number 138 of the Louis XIII *Cabinet d'Armes* (see No. 40). The lock is of unusual construction and is attached to a wheel-lock plate of Italian form.

The steel and pan-cover are combined in one member and a large stop is screwed in front of the cock to arrest its fall. The scear is of wheel-lock type and works horizontally, engaging on a raised ledge on the tumbler. There is no provision for half-cock. On the inside of the lockplate is a maker's mark, a crowned double-headed eagle over the initials G.M. A similar gun in the Polish Army Museum, Warsaw, bears the maker's mark M.K. over a running unicorn in a shield, both on the inside of the lock-plate and on the top of the barrel.

Lit. T. Lenk. *Flintlåset.*

42. PLATE XVII. FLINT-LOCK RIFLE, *Russian; second half of seventeenth century.*

Joicey Bequest. Length 58 in. M.228–1919

The walnut stock with butt of German form is inlaid with horn plaques, that on the cheek-piece is engraved with a bust of the Virgin flanked by angels and stags. The remaining plaques are engraved with hunting subjects. The flint lock is of conventional construction, the plate engraved with dragons. The rifled barrel of octagonal section expanding towards the muzzle. It is damascened with silver at breech and muzzle. There is a V backsight and blade foresight.

43 PLATE XVIII. PLATE I FROM A PATTERN BOOK OF ORNAMENT FOR FIREARMS, by Philippe Daubigny. *French (Paris); dated* 1635. E.1312–1912

This book contains thirteen designs for wheel-lock and flint-lock fire-arms on nine sheets, signed *Philippe Daubigny*. The first edition of Philippe Cordier Daubigny's designs was published about 1635; this plate is taken from the second edition, published in Paris by Van Merlen about 1665. The date has been roughly altered on the plate from 1635 to 1665.

The designs are of considerable help in dating early French flint-locks. The author, who was evidently a professional engraver of gun mounts, belonged to a family of gun-makers. Two other members are known: Isaac Cordier and Jean Cordier. The former is known to have worked at Fontenay and Paris.

It is probable that Philippe also worked as an engraver in Paris.

Lit. J. F. Hayward: *The Art of the Gunmaker* (2nd ed.), 1965, Vol. I, pp. 276, 277.

44. PLATE XVIII. SHEET OF DESIGNS FOR WHEEL-LOCK FIREARMS from *Plusieurs Pieces d'Arquebuzerie Receuillés et Inventées Par François Marcou Maistre Arquebuzier à Paris. French (Paris); dated 1657* E.1050–1908

This plate is number three from the set of sixteen and title-page. It is signed 'C. Jacquinet fec. Marcou excudit cum privil'. The first and last sheets of the set are dated 1657, in which year it was presumably published; François Marcou was a Paris gunmaker, a portrait bust of him appears on the page following the title page. He was born in 1597, and the designs seem to cover the whole of his working life as a *Maître-Arquebusier* up to the year of publication. They illustrate the course of fashion for some thirty years from about 1630 or a little earlier until 1657.

45. PLATE XIX. FLINT-LOCK PISTOL, *the stock mid-seventeenth century, the lock renewed early in the eighteenth century. German (Rhineland?).*
Given by Mr. A. B. Bradley. Length 9½ in.
 M.79–1953
The stock, made for the original wheel-lock, is of walnut inlaid with silver wire and with silver plaques engraved with a Pelican in her piety, a crowned double-eagle and a crown supported by lions rampant. The triggerguard and butt cap of iron, the latter engraved with a crown supported by two lions. Iron belt hook.

The lock is of conventional flint-lock construction but has a wheel-lock profile corresponding to the recess in the stock.

The barrel octagonal at the breech, sixteen sided at the muzzle.

A number of wheel-lock firearms of German origin and apparently stocked by the same master as this are known, see No. 38 in this catalogue and also J. F. Hayward, *The Art of the Gunmaker*, Vol. I (2nd ed.), 1965, p. 172.

The pair to this pistol is in the Museo Poldo Pezzoli, Milan (No. 3219).

46. PLATE XIX. DOUBLE MIQUELET LOCK FROM A GUN FIRING TWO SUPERIMPOSED CHARGES. *Italian; mid-seventeenth century.*
Length 11¼ in. 172–1869
The mainsprings and steel-springs shaped like grotesque figures and provided with chiselled bridles, the cocks chiselled with human figures. The top-jaw screw heads of loop form. The rear tip of the lock wrought in high relief with a grotesque mask.

See also No. 39, which apparently comes from the same region.

47. PLATE XIX. MIQUELET LOCK PISTOL. *Spanish; third quarter of seventeenth century.*
Farquharson Bequest. Length 15 in.
 M.669–1927
Walnut stock with hexagonal fish-tail butt inlaid with panels of iron engraved with Baroque foliage. Iron mounts. The lock undecorated, separate steel spring. The barrel octagonal at breech and circular at the muzzle, secured to the stock by a ring.

48, 49. PLATE XX. TWO PRINTS FROM ENGRAVED FLINT-LOCK COCKS, in the early manner of François Marcou. *French; about 1640–50.* E.1924, E.1919–1946
Compare Plates 5 and 9 of Marcou's *Plusieurs Pieces d'Arquebuzerie.* These prints were made by the engraver, probably as a record of the designs he had executed.

50, 51. PLATE XX. TWO PRINTS FROM ENGRAVED SIDE PLATES, in the early manner of François Marcou. *French; about 1640–50.*
 20125, 19057
Compare Plates 2 and 5 of Marcou's *Plusieurs Pieces d'Arquebuzerie.*

52. PLATE XX. PRINT FROM AN ENGRAVED LOCK-PLATE, in the later manner of François Marcou. *French; third quarter of seventeenth century.*
Compare plate 16 of Marcou's *Plusieurs Pieces d'Arquebuzerie.*

53. PLATE XX. PRINT FROM AN EN-
GRAVED SIDE-PLATE. *French; about 1680.*

E.1917–1946

54. PLATE XXI. FLINT-LOCK HOLSTER
PISTOL WITH TWO LOCKS FOR FIRING TWO
SUPERIMPOSED CHARGES IN SUCCESSION
FROM ONE BARREL. *French; about 1630–40.*

Transferred from the Rotunda Museum, Wool-
wich. Length 29 in. M.8–1949

Stock of pearwood, butt cap, fore-end and
ramrod pipe (defective) of gilt copper pierced
and engraved with floral ornament of a
type familiar on seventeenth-century watch
cases.

The barrel is cut with three slender longi-
tudinal ribs, the top one of which extends the
whole length of the barrel, while the other two
reach to a third of its length only. Normal
flint-lock mechanism, the right-hand lock fires
the first charge, the pan communicating with
the forward touch-hole by means of a channel
cut in a metal strap running along the side of
the barrel. The locks are of early type, and
have an unusual feature in the safety-catch, a
stud on the outside of the lock-face which
when pushed to the rear, slides a bolt into a
recess cut in the spindle of the cock. The
two locks are fired successively by the single
trigger.

The lock-plates were formerly engraved with
floral designs and gilt, en suite with the mounts,
but only traces of this ornament are now
visible.

This pistol is one of a number removed from
the Paris Arsenal and sent to England at the
end of 1815. In view of its source, general
appearance and unusual construction, it seems
highly probable that it originally belonged to
the *Cabinet d'Armes* of Louis XIII. There is,
however, no trace of an inventory number on
the stock, nor is it possible to identify the pistol
in the fairly detailed descriptions of the Louis
XIII inventory. The number stamped on the
stock is that of the Woolwich Museum. The
pair to this pistol is now in the Polish Army
Museum, Warsaw, to which it was probably
transferred from the Berlin Zeughaus in 1945.

It was probably taken from Paris to Berlin
in 1815.

55. PLATE XXI. WHEEL-LOCK GUN.
*Italian (Brescia); second quarter of the seventeenth
century.*

Length 49½ in. M.7–1962

The burr walnut stock inlaid with panels of
lace-work in steel pierced with figures amidst
scrolls. On the stock opposite the lock a
standard for a strap attachment. Boat-shaped
trigger-guard pierced and chiselled with
foliage.

The barrel, polygonal at the breech and
round at the muzzle end, is engraved under-
neath with the initial A, and signed above
Gio. Batt. Francino. The lock, with two cocks,
is chiselled with masks and foliage and stamped
underneath with the initials G.A.G. under a
crown within a circle of Giovanni Angelo
Gavacciolo.

Gavacciolo was one of the finest Brescian
masters of the time. In his manuscript treatise
L'Arte Fabrile of 1642, Antonio Petrini de-
scribes him as the most gifted master of chisel-
ling in low relief. He signed the locks of a
garniture of wheel-lock gun and brace of
pistols made for Louis XIII and subsequently
presented by him to Queen Christina of
Sweden.

Lit. J. F. Hayward: *Art of the Gunmaker,*
Vol I (2nd ed.), 1965, pp. 213–14.

56. PLATE XXII. SHEET OF DESIGNS,
numbered 6, from the *Plusieurs Models des plus
nouvelles manieres qui sont en usage en l'Art
d'Arquebuserie,* engraved by C. Jacquinet from
firearms made by the Parisian gunmakers,
Thuraine and le Hollandois, and published in
Paris about 1660. E.1927–1946

This work was engraved by the same C.
Jaquinet who signed the Marcou pattern book
(No. 36). Thuraine and le Hollandois held the
appointment of *Arquebusiers Ordinaires* to the
King of France. Le Hollandois was, as the
name implies, of Dutch or Flemish origin; his
real name was Adriaen Reynier. The orna-
ment consists of fine engraved work and shows
strongly the influence of contemporary jewel-
lers' designs.

57. PLATE XXII. WHEEL-LOCK, the plate chiselled with hunting scenes in low relief. Signed *C. Öfner à Insbrug. Austrian (Innsbruck); first half of eighteenth century.*

Given by Mr. S. J. Whawell. Length 9⅝ in.

M.540–1924

The very fine chiselling on this lock is signed by the artist on a rock in the foreground with the monogram *IMK*.

58. PLATE XXII. MIQUELET LOCK. *Italian; eighteenth century.*

Farquharson Bequest. Length 6¼ in.

M.498–1927

The working parts of the lock are chiselled with human figures in the round, the lock-plate with grotesque masks. Signed inside the plate *Domenico Santi Montealboddo.*

59. PLATES XXIII AND XXV. PAIR OF FLINT-LOCK HOLSTER PISTOLS. *Italian; mid-seventeenth century.*

Ramsbottom Bequest. Length 22⅝ in.

M.2800, 2800a–1931

The walnut stocks slightly carved and inlaid with stag-horn scrolls. The trigger guards of steel chiselled in the form of a merman, the pommels chiselled in high relief with reclining nude figures amongst trees and flowers. The cocks chiselled in the form of a baby merman whose tail develops into a dragon's head. The lock-plates still have the downward extension of the wheel-lock.

The barrels, octagonal at the breech, are chiselled with longitudinal panels of foliate scrolls. The forward part of the barrel is polygonal and engraved at each end with a wreath of foliage.

This construction known as the 'Roman lock' was produced in central and southern Italy. In the absence of a signature it is not possible to place it more exactly. Certain details of the carved ornament on the stocks seem to belong to a period later than the mid-seventeenth century and may have been added during the eighteenth century. For a discussion of lock constructions of this type see S. V. Grancsay, 'Firearms of the Mediterranean' Parts I and II. *The American Rifleman,* February, March, 1949.

60. PLATE XXIII. PAIR OF SNAPHAUNCE HOLSTER PISTOLS. *North Italian (Brescia); mid-seventeenth century.*

From the Bernal Collection, Sale Catalogue, Lot No. 2671. Length 21 in. 2242, 2242a–1855

The walnut stocks are inlaid with panels of pierced steel tracery engraved with hunting scenes within interlacing foliage. The horn fore-ends a later restoration. The mounts of pierced and chiselled steel, the pierced pommel lined with yellow silk. The locks chiselled in high relief with monsters and foliage, are signed on the inside of the lock-plate with the initials V. F. over a pellet in a heart-shaped shield. The barrels are of octagonal section at the breech, the forward part decorated with herring-bone file-work. They are signed *Lazarino Cominazzo.* The excellence of these barrels is such as to suggest that they may be the work of the great Brescian barrel-smith himself.

The execution of the piercing and engraving on the steel panels inset in the stocks of these pistols is of the highest quality.

61. PLATE XXIII. PAIR OF FLINT LOCK HOLSTER PISTOLS. *North Italian (Brescia); third quarter of seventeenth century.*

Farquharson Bequest. Length 22½ in.

M.664, 664a–1927

The walnut stocks are inlaid with panels of pierced brass tracery engraved with snakes and dragons within floral scroll-work. The mounts of brass, pierced and chased, with the exception of the trigger-guards which are eighteenth-century replacements.

The locks, engraved with floral scrollwork, are signed *Pietro Alzano, Brescia.*

The barrels, of octagonal section at the breech, the forward part polygonal, are signed *Lazarino Cominazzo* and stamped underneath with the letter L.

62. PLATE XXIV. FLINT-LOCK PISTOL. *North Italian (Brescia); last quarter of seventeenth century.*

Farquharson Bequest. Length 19 in.

M.490–1927

The iron stock is signed on the trigger-guard

Scioli in Brescia. The surface of the butt is engraved with interlacing floral scrolls, the mounts chiselled with scrolls terminating in dragon's heads, the butt cap with a bust portrait of a Roman Emperor. The lock is signed *Scioli in Bᵃ*, the barrel *Giovani Battista Franzino.*

Though pistols stocked entirely in iron were usual in Germany in the sixteenth century and not unknown in the seventeenth century (Jan Cloeter of Grevenbroich), Stefano Sciolo (also spelt Scioli and Cioli) seems to have been the only Brescian gunmaker to have made iron stocks. Several are recorded, all fully signed by Scioli. A very similar pair of pistols in the Wallace Collection (Nos. A.1229/30) are signed by this maker and have barrels by G. B. Francino. After those of Lazarino Cominazzo, the barrels of G. B. Francino were the most highly esteemed amongst the production of the Brescian barrel-smiths.

For a list of other examples of firearms by these makers, see Wallace Collection Cat. Vol. II, pp. 563 and584. There is an unsigned pair of pistols, apparently stocked by Scioli in the Instituto de Don Juan de Valencia, Madrid, Nos. 167–8. See also G. M. Silverstolpe, 'An uncommon flint-lock construction during the middle of the seventeenth century'. *Livrustkammaren*, Vol. IV, 7.

63. Plate **XXIV**. PAIR OF FLINT-LOCK PISTOLS. *North Italian (Brescia); about 1670–80. Ramsbottom Bequest.* Length 15½ in.

M.2799, 2799a–1931

The walnut stocks are inlaid with panels of pierced steel engraved with monsters amidst foliate scrollwork. The mounts of pierced and chiselled steel; the pommels are lined with red cloth, which may be seen through the piercing.

The locks, signed *Pietro Bello*, are chiselled with conventional foliage.

The barrels, octagonal at the breech, are ornamented with 'herring-bone' file work, and signed *Bernardi Bazzone.*

These pistols were originally equipped with belt-hooks, now removed.

64. Plate **XXIV**. WHEEL-LOCK BELT PISTOL. *North Italian (Brescia); mid-seventeenth century.*

From the Shandon Collection and Gurney Collection. Sale Catalogue 8 March 1898. Lot 260. Length 16¼ in. M.262–1923

The walnut stock is inlaid with panels of finely-pierced and engraved tracery. The mounts of steel, chiselled in high relief with monsters and with floral scrollwork. The butt cap is lined with red cloth, which can be seen through the pierced tracery. There is a belt-hook. The lock has a chiselled border of flowers and fruit, the wheel is chiselled with a male term whose body develops into floral scrolls, the arm of the pyrites holder is formed as a dolphin. The barrel, octagonal at the breech, the forward part polygonal, is signed *Lazarino Cominazzo.* The signature is much rubbed, and the spelling is therefore uncertain The pair to this pistol was in the collection of Signor L. Marzoli, Palazzolo sull'Oglio, Brescia.

65. Plate **XXV**. SNAPHAUNCE LOCK, chiselled with Hercules overcoming the Nemean lion, Leda and the Swan and a Triton blowing a horn. *North Italian (Brescia); third quarter of seventeenth century.* Length 4⅝ in. M.362–1923

Exhibited at Ironmongers' Hall Exhibition, May 1861. Illustrated in catalogue, p. 175.

66. Plate **XXVI**. PAIR OF FLINTLOCK HOLSTER PISTOLS. *English(?); about 1660–80,* the barrels probably the work of Hans Keiner of Eger.

A. S. Hobson Bequest. Formerly the property of the Earl of Hyndford. Length 20 in.

129, 129a–1878

The mounts of engraved and slightly chiselled iron. The stocks of burr wood, terminating in horn fore-ends.

The locks engraved with trophies of arms.

The barrels, which are rifled with seven grooves, are octagonal at the breech and finely chased with foliate scrollwork enclosing naturalistically treated flowers. This ornament covers the whole of the surface of the barrels with the exception of the breech strap.

The stocks, locks and furniture of these pistols are very similar to English work of this period, but the fine chasing on the barrels is

typical of the manner of the Sudeten-German gunsmith Hans Keiner, see H. Schedelmann. 'Der Büchsenschmied Hans Keiner als Meister deutschen Eisenschnitts', *Zeitschrift für Hist. Waffenkunde*, N.F. VII, 1942, p. 149. Similar flower designs are, however, found on firearms made elsewhere in Germany, as for example on the lock of a wheel-lock rifle in the Tower of London signed by Andreas Prantner of Regensburg. It is not impossible that the first Earl of Hyndford (1638–1710), to whom the pistols probably belonged, had this fine pair of barrels stocked up in England. The engraved and chiselled ornament on the lock and mounts appears to be the work of a different and less skilled hand than that on the barrel.

67. PLATE XXVII. FLINT-LOCK BREECH-LOADING MAGAZINE GUN, the barrel and lock are signed *John Cookson. English; about 1680.*

Length 49 in. 77–1893

The stock of burr walnut, the lock-plate and mounts of iron chiselled in relief and engraved with grotesque masks and monsters.

This type of breech-loading magazine gun is usually known as the Lorenzoni system after the Florentine gunmaker Michele Lorenzoni, who made many of them. It was, however, produced by gunmakers elsewhere in Europe, and it is impossible to determine to whom credit for its invention should be given. For a description of the operation of this gun, see p. 26.

68. PLATE XXVIII. SHEET OF DESIGNS FOR ENGRAVED AND CHISELLED ORNAMENT ON FLINT-LOCK PISTOLS. Number 6 from *Plusieurs Pieces et Ornements Darquebuzerie*, engraved by Claude Simonin, and published in Paris in 1685. E.3076–1910

The work consists of a title page and seven sheets of designs numbered 2 to 8. A second edition was published in 1705. As in the case of other pattern books, the designs are drawn from the works of Parisian gunmakers and represent the style which had been fashionable in Paris for about a decade prior to the date of publication. Le Languedoc, whose name appears on the barrel at the bottom of the sheet, was one of the most distinguished Parisian gunmakers of the last decades of the seventeenth century and the early decades of the eighteenth century.

69. PLATE XXVIII. SHEET OF DESIGNS FOR ENGRAVED AND CHISELLED ORNAMENT ON FLINT-LOCK PISTOLS. Number 6 from *Plusieurs Pieces et autres Ornements pour les Arquebusiers*, engraved by Claude Simonin and his son, Jacques Simonin, and published in Paris in 1693. E.3089–1910

This work consists of title page and ten plates numbered 2 to 11; though published eight years later, the designs in this pattern book do not differ in style from those in the earlier work.

70. PLATE XXIX. FLINT-LOCK HOLSTER PISTOL. *English; late seventeenth century.*

Farquharson Bequest. Length 16 in.

 M.676–1927

Walnut stock, the mounts slightly engraved, the side-plate pierced and chiselled with foliations. Rifled barrel, unscrewing at the breech to permit breech loading. The barrel is secured to the stock by a ring sliding on a rod; this device was necessary to free one hand when loading on horseback. The barrel stamped with the proof marks of the London Gunmakers' Company. The lock signed 'Fisher'. The somewhat perfunctory finish of this pistol is hardly up to the usual London standard. Three gunmakers named Fisher, probably father and two sons, are recorded in the Gunmakers' Company in the third quarter of the seventeenth century.

71. PLATE XXIX. FLINT-LOCK POCKET PISTOL. *English; about 1690.*
Given from the collection of Col. G. Stovell.
Length $5\frac{1}{4}$ in. M.185–1928

The figure of the wood stock has been heightened artificially. Octagonal barrel forged in one with the lock.

The lock-plate and barrel engraved with birds and foliage. Signed on the upper face of the barrel *Wornall Londini*.

72. PLATE **XXIX**. FLINT-LOCK TURN-OFF PISTOL. *English (London); about 1725-30. Given by Mr. H. Furmage.* Length 11¼ in.

M.555-1924

The lock, signed *W. Turvey, London,* the walnut stock slightly carved, mounted with silver and inlaid with silver wire filigree. The barrel of 'cannon' form unscrews at the breech to allow the charge to be inserted directly into the chamber.

This type is commonly referred to as a Queen Anne cannon-barrelled pistol, but this term is of recent introduction. The great majority date from after the death of Queen Anne in 1714. The sparse silver wire inlay on this pistol dates it early in the eighteenth century. Subsequently the inlay became much more profuse. Members of the Turvey family are recorded as gunmakers during the late seventeenth century and first half of the eighteenth century. W. Turvey, the maker of this example, was probably the son of E. Turvey who was at work circa 1700.

Lit. J. F. Hayward, 'English Screw-barrelled pistols, 1700-1750'. *Apollo,* Vol. XL, p. 114.

73. PLATE **XXIX**. FLINT-LOCK PISTOL. *Scottish; mid-eighteenth century.*

Farquharson Bequest. Length 11¾ in.

M.653-1927

One of a pair, signed on the locks *Io Murdoch* of Doune. Scroll ended butt inlaid with interlacing scrolls and two oval panels of silver. The pricker and trigger have silver button finials. The barrel fluted at the breech, octagonal at the muzzle and engraved with foliate scrolls.

74. PLATE **XXX**. PAIR OF FLINT-LOCK PISTOLS. *North Italian (Brescia); late seventeenth century.*

Given from the collection of Col. G. Stovell. From the Magniac Coll. Christies, July 2/4. Lot 885-6. Length 19½ in. M.178, 178a-1928

The stocks signed *Filippus Spinonus fecit.* The butts of brass, chased with interlacing foliage enclosing animals, birds and monsters. The stocks of walnut inlaid with steel and brass tracery engraved with foliage enclosing birds

and animals in the characteristic Brescian manner. Each pistol is signed on a scroll inlaid in front of the trigger-guard; as the signature is on the stock, it would appear that Spinoni (lat. Spinonus) was a gun-stocker.

The whole surface of the locks is chiselled in high relief with foliage and with animals.

75. PLATE **XXX**. FLINT-LOCK PISTOL. *Silesian (Teschen); about 1680.*

Purchased from the funds of the *Farquharson Bequest.* Length 19 in. M.33-1951

The stock is inlaid with mother of pearl and staghorn, the latter engraved with hares, hounds, a squirrel and an exotic bird.

The barrel is blued and decorated with reserved panels of punched scroll-work, these latter being gilt.

The lock is blued and damascened with flowers in silver.

This pistol belongs to the same group as three other pieces in the Museum, the wheel-lock rifle (M.101-1930) and the wheel-lock Tschinkes (2217, 2218-1855).

76. PLATE **XXX**. PAIR OF FLINT-LOCK PISTOLS. *Bohemian (Prague); about 1720-30.* Length 22 in. 518, 518a-1872

The locks are signed *I. Deplan a Prag.* The stocks of walnut slightly carved, the mounts of gilt bronze cast and chased with hunting scenes. The pommel caps in the form of grotesque masks. On the thumb-plate is engraved a bust figure surmounted by a crown with two female supporters. The barrels of circular section with longitudinal sighting rib. Stamped in the Spanish manner at the breech, the signature *Joann. Deplan,* above, three fleur-de-lis, below, an elephant.

The lock-plates are chiselled with hunting subjects.

77. PLATE **XXXI**. PAIR OF FLINT-LOCK CANNON-BARRELLED PISTOLS. *Flemish; about 1720-30.*

Purchased from the funds of the Farquharson Bequest. Length 15½ in. M.196-1951

The stocks are entirely of silver, the butts decorated with grotesque masks, the remainder

engraved with Baroque scrollwork. The thumb-plate escutcheon is engraved with the arms of the Counts of Bethlen de Bethlen in Hungary: *azure, a snake crowned, holding an orb between its teeth.*

The cannon barrels are rifled with seven grooves; there are no sights.

The ramrod is of steel, the top fits into a ramrod pipe screwed to the underside of the barrel in front of the trigger-guard.

The locks are signed *Devillers à Liège*.

Unlike the usual English type of cannon-barrelled pistol, these examples have fixed barrels and must be loaded from the muzzle. Though in most respects they resemble the English pattern of the early eighteenth century, they were most probably modelled on a French prototype. At the time that these pistols were made, Liège was part of the Austrian Netherlands, and it is not therefore surprising to find a Hungarian Count purchasing fire-arms there.

78. PLATE XXXI. FLINT-LOCK PISTOL WITH THREE BARRELS. *Italian (Florentine); about 1680.*

Farquharson Bequest. Length 11 in.

M.677–1927

The lock is signed *Lorenzoni*. Burr walnut stock, the iron mounts finely chiselled with scrollwork. On the butt a faun's mask chiselled in high relief. Inlaid in the stock, behind the barrel-tang, an heraldic escutcheon chiselled with the Medici arms surmounted by the Medici Crown.

The lock-plate is engraved with a figure of a huntsman discharging a fowling-place, and with foliate scrollwork.

The breech ends of the three barrels are enclosed by a sleeve, through which the touch hole passes. The barrels are revolved by hand, the lock had also to be cocked and primed between each shot. The trigger-guard operates as a locking device: when pressed upwards, it disengages from a slot cut in the sleeve and permits the barrels to revolve.

This pistol was made for Cosimo III, Grand Duke of Tuscany (1670–1723), or a member of his family. A fowling-piece by the London

gunmaker, Dolep, in the Armeria Reale, Turin (No. 1105) bears the same coat of arms on the barrel and the initials 'F.M.' in cypher inlaid in the butt, and probably belonged to Ferdinando de Medici (1663–1713), eldest son of Cosimo III.

Michele Lorenzoni was the foremost Florentine gunmaker of his time, and a number of firearms made by him are preserved with other guns from the Medici collection in the Bargello, Florence. He specialized in the production of breech loading magazine guns: two guns of this type, both signed by Lorenzoni, are in the Armeria Reale, Turin (Nos. M.64 and M.65).

The Dresden records show that the Kurfürst Johann Georg bought a repeating gun from Michele Lorenzoni in 1684 (Seidlitz, *Die Kunst in Dresden*, Vol. IV, p. 503). A snaphaunce lock (M.546–1924) in the Museum collection is signed *Michael Lorenzonus*.

Lit. Gaibi: *Armi da Fuoco*.

79. PLATE XXXI. FLINT-LOCK PISTOL. *Spanish (Barcelona); mid-eighteenth century.*

Ramsbottom Bequest. Length 16⅝ in.

M.2804–1931

One of a pair, carved walnut stock with cast and chased silver mounts stamped with Barcelona town-mark and maker's mark *vila*. Lock of French construction chiselled with masks and foliage. Barrel of octagonal section at breech, polygonal at muzzle, the breech inlaid with silver and stamped with the signature of *Esteva* and the Barcelona town mark.

The Barcelona gunmakers favoured the French lock in preference to the Madrid lock, which is found on most mid-eighteenth century Spanish pistols of fine quality.

Lit. J. Lavin: *Spanish Firearms*, p. 260.

80. PLATE XXXII. PLATE NUMBERED 9 from the *Diverses Pieces d'Arquebuserie* engraved by Nicholas Guérard, *Paris n.d.; about 1700.*

This work consists of ten plates including the title page. The designs are intended to be executed in chiselled steel against a gilt ground. The ornament on the stocks is intended to be inlaid in cut and engraved silver sheet or in

silver wire. The engraver Nicholas Guérard was, like his predecessors in the publication of pattern books, probably an engraver of fire-arm mounts by profession. The text on the title-page states that the engravings were executed 'Sous la conduite des plus habiles Arquebusiers de Paris'. This pattern book had considerable influence; its designs reflect the style of Bertrand Piraube, arquebusier to Louis XIV, who was granted *logement* in the Louvre in January, 1670. It was subsequently re-issued in a German edition by J. C. Weigel, published in Nürnberg. Amongst the firearms illustrated here, number 68 appears to be based on Guérard. The design for silver inlay in a gun-stock shown in this plate was repeatedly used at the Russian Imperial Arms Factory at Tula.

81. PLATE XXXII. SHEET OF DESIGNS FOR ENGRAVED AND CHISELLED ORNAMENT ON FLINT-LOCK FIREARMS, from the *Nouveaux desseins d'Arquebuseries*, engraved by De Lacollombe and published in Paris in 1730. The sheet illustrated is signed *De Lacollombe Fecit*. E.212–1927

Sheet numbered 4 from a set of twelve with title page, consisting partly of the work of De Lacollombe and partly of the work of Gilles Demarteau, see also 82.

82. PLATE XXXIII. SHEET OF DESIGNS FOR CHISELLED AND CARVED ORNAMENT ON FLINT-LOCK FIREARMS, signed *De Marteau Fecit* and dated 1749.
 E.219–1927

De Marteau seems to have added a number of plates at various later dates to the De Lacollombe set, which was published in 1730. His designs show the full effect of the French Rocaille fashion, while the sheets signed by De Lacollombe are still in the French *Régence* style.

83. PLATE XXXIV. FLINT LOCK FOWLING PIECE. *Russian (Tula); about 1778.* Length 54 in. M.3–1961
Walnut stock inlaid with silver wire scroll-work, the mounts of blued steel encrusted with sprays of roses in gold. The lock signed in cyrillic characters *A. Leontiew*, inlaid in gold, the rear of the lock-plate chiselled with trophies of arms, the barrel chiselled and gilt at the breech with Hercules fighting the Hydra against a punctate gilt ground, and towards the muzzle with a composition of foliated scrolls enclosing grotesque masks. From the armoury of the Earls of Pembroke, Wilton House, Salisbury.

The maker of this gun, Archip Leontiev, is recorded in the archives of the Tula factory as a gunsmith and steel-chiseller between 1755 and 1778 but these years do not necessarily mark the dates of his joining and leaving the factory. The gun must have belonged to an eighteenth century member of the Herbert family, almost certainly Lord George Augustus Herbert (1759–1827) who in the course of the Grand Tour travelled in Russia between August 1778 and February 1779, when he is known to have sent a gun back to England.

Lit. C. Blair: 'Archip Leontiew's Gun'. *Connoisseur*, February, 1962, p. 116.

84. PLATES XXXIV, XLI. FLINT-LOCK FOWLING PIECE. *South or Central Italian; second quarter of the eighteenth century.*

Given by Mr. W. Russell. Length 67 in.
 M.43–1938

The half-length walnut stock is slightly carved. The mounts are, with the exception of the butt-plate and thumb-plate which are of silver parcel gilt, of gilt brass encrusted with finely-chased panels of silver. The ornament consists of classical busts chased in high relief in silver, surrounded by panels of silver, chased with arabesque designs against a punched ground, and inset in the gilt frame of the mounts.

The lock of usual construction is signed *C. Galavrino*. It is finely chiselled with arabesques enclosing animals and monsters.

The barrel of octagonal section at the breech is inlaid with chased silver panels and with brass strapwork against a brown ground. The remainder of the barrel of circular section. Chased silver foresight.

85. PLATE XXXV. FLINT-LOCK RIFLE. *Bohemian; first half of eighteenth century.*

Purchased from the funds of the Farquharson Bequest. Length 44½ in. M.120–1953

Walnut stock with cheek-piece carved with foliage and inlaid with silver wire foliage terminating in husks and masks. Silver furniture, the butt plate cast and chased with Diana enthroned under a baldachin; on the side plate a hunting scene, on the patch-box cover Diana in a chariot. Normal flint-lock with flat surface, chiselled with a huntsman kneeling before Diana, signed *Poser a Prag*. The barrel of octagonal section throughout its length is rifled with seven grooves. The breech is signed *Paul Poser* in gold letters against a blued ground, and the barrel is further decorated with gold lines. Silver back and foresights.

The fine-chiselled ornament is probably the work of the Prague artist, H. Matzenkopf, who subsequently went to Salzburg as Medal Die-cutter to the Archbishop of Salzburg.

The pair to this rifle is believed to be in an American private collection.

86. PLATE XXXV. FLINT-LOCK FOWLING-PIECE. *Russian (probably Tula); first half of eighteenth century.*

Purchased from the funds of the Farquharson Bequest. Length 54½ in. M.47–1954

Walnut stock with cheek-piece inlaid with silver wire scrolls following the profile of the mounts. The latter are of silver, chiselled with masks and foliage against a gilt ground. The lock of conventional construction with flat surface is encrusted with scrollwork in gold. The barrel of round section with longitudinal sighting rib is encrusted with a Roman warrior under a baldachin at the breech and with three panels of gold scrollwork.

Below the cheek-piece is stamped the name G. V. Spee, perhaps that of a former owner.

87. PLATE XXXVI. WHEEL-LOCK RIFLE. *South German (Munich); early eighteenth century. From the Bernal Collection,* No. 2218. Length 42 in. 2194–1855

The burr walnut stock is carved with scrollwork in low relief and inlaid with panels of gilt brass chiselled and engraved with scrollwork. On the inner side of the trigger-guard is engraved the figure 1, indicating that this rifle was one of a pair, or part of a garniture of rifle, fowling-piece and brace of pistols. Mounts of engraved and gilt brass. Octagonal twist barrel rifled with eight grooves, inscribed in letters of silver inlaid over the chamber *Georg Exl*. V-backsight with folding leaves, blade foresight. Wheel-lock with internal wheel, the surface chiselled with a cavalry combat between Turkish and European troops. Trophies of Turkish arms are also engraved on the lock and on the sliding patch box cover. The lock is signed *Christopher Jos. Frey in Minch* (München).

The scrollwork on the stock is in the German Baroque *Knorpelwerk* style and appears to be derived from the engraved ornament of Johann Smischek of Prague who published his *Neues Groteschgen Büchlein* about the middle of the sevententh century. The ornament on the lock, showing battle scenes against the Turks, is typical of Bavarian and Austrian firearms of the late seventeenth and early eighteenth century. A wheel-lock in the Museum (719–1877) is engraved with a representation of the defeat of the Turks before Belgrade in 1717. It is signed *M. Muck fec.*

88. PLATES XXXVI, XXXVII. FLINT-LOCK FOWLING-PIECE. *German (Gotha); dated 1724.*

Purchased from the funds of the Farquharson Bequest. From the *Gewehrkammer* of the Grand Duke Ernst August of Saxe Weimar. Length 55 in. M.65–1950

The walnut stock of half length, carved with shells and foliate scrolls. Silver mounts, chased and engraved with strapwork and classical bust figures, in the manner of the engraved designs of De Lacollombe, published in Paris about 1700. On the thumb plate, the arms of Saxony, surmounted by a Grand-ducal crown.

The lock engraved with the figure of a huntsman in contemporary dress and with foliate scrolls. Signed *Tanner à Gotha.* 1724.

Octagonal barrel of watered (Damascus) steel, the surface etched to bring up the pattern.

In view of the Saxon arms on the thumb plate, this gun must have been made specially for the use of the Grand-Duke Ernst August of Saxe Weimar. It was preserved until 1927 in the Saxe Weimar *Gewehrkammer* in Schloss Ettersburg in Saxony. Peter Tanner of Gotha (1666–1750) was a gunmaker of considerable note and firearms signed by him are to be found in many of the larger collections of firearms formed in Germany during the eighteenth century. He held the office of *Fürstlicher Hofbüchsenmacher* to the Dukes of Saxe-Coburg-Gotha.

89. PLATES XXXVI, XXXVII. FLINT-LOCK FOWLING-PIECE. German (*Thuringia*); *about* 1750. Formerly in the Figdor Collection, whence it passed to the Oesterreichisches Museum, Vienna.

Purchased from the funds of the Farquharson Bequest. Length 54⅞ in. M.54–1949

The carved walnut stock is inset with plaques of iron, chiselled and gilt, and inlaid with silver wire. The mounts of iron, finely chiselled and gilt, the side-plate with hounds within a landscape, the butt-strap with stags in a forest, and the butt-plate with a fallen stag amongst hounds. On the thumb-plate escutcheon is chiselled a male bust, perhaps the owner. On the tang of the ramrod pipe, a female bust, perhaps a portrait of the owner's spouse.

The lock-plate chiselled and gilt with deer and a landscape enclosed within rococo scroll borders.

The barrel of circular section, with a longitudinal sighting rib along the top; at the breech, a panel chiselled with a gentleman in mid-eighteenth-century costume carrying a fowling-piece accompanied by a dog within a garden background with a temple. At the muzzle a composition of asymmetrical scrollwork.

Though this gun is unsigned, the design of the ornament and the excellent quality of the chiselling point to the Stockmar workshop at Heidersbach near Suhl in Thuringia. This workshop consisted of the father, Johann Nikolaus Stockmar, his two sons, Johann Christoph and

Johann Wolf Heinrich and a fourth member, Johann Georg, whose precise relationship to the others has not been established. The father and both sons were appointed *Kurfürstlicher Hofgraveur*, a position which the father held from 1731 to 1745. Although they were called engravers, they were, in fact, firearm decorators to the Saxon court, and most of the fine arms embellished by them were intended for the Elector's own use, for members of his court, or as gifts to foreign princes. They were usually made in sets of a brace of pistols, a fowling-piece and a rifle. Two complete sets exist in England, one in the Wallace Collection (Nos. A.1203/4, 1119/1120, 1362), the other in the Royal Collection at Windsor Castle (Nos. 485–6, 423, 405). In each case the rifle only is signed, the Wallace Collection example by J. C. Stockmar and that in Windsor Castle by J. G. Weiss of Goldlauter bei Suhl. All the recorded Stockmar guns belong to the same period, about 1730 to 1760, and show the most flamboyant rococo taste.

Lit. *Connoisseur*, Vol. CXXIV, No. 514, p. 128 ff.

90. PLATES XXXVII, XXXVIII. PAIR OF FLINT-LOCK HOLSTER PISTOLS. French (*Paris*); *about* 1750–60.

From the Bernal Collection. Lot 2675. Length 19½ in. 2243, 2243a–1855

The locks are signed *Les La Roche aux Galleries du Louvre*.

The walnut stocks are slightly carved with scrollwork and profusely inlaid with symmetrically arranged scrollwork in gold wire. On the upper side of the butt is inlaid on the one pistol, a fleur-de-lis, and on the other, the cypher of Louis XV, King of France. The escutcheon plates of gold bear the royal arms of France.

The steel mounts are chiselled in unusually high relief against a gold-plated ground, the ornament differing on each pistol. No. 1 on pommel, (*a*) Apollo, (*b*) Jason with the golden fleece, (*c*) (on pommel cap) Prometheus bound to a rock. No. 2 (*a*) Achilles and Patroclus, (*b*) Medea killing her children, (*c*) (on pommel cap) Milo devoured by wolves.

The locks are chiselled in high relief with figure subjects against a gold plated ground, as follows:

No. 1. Medea brewing poison, and (on pan-cover) Diana with Cupid. No. 2. Amphitrite, and (on pan-cover) Neptune.

On each of the cock screws is chiselled a profile head of Louis XV. The barrels are chiselled at the breech end against a gold-plated ground with (No. 1) Hercules overcoming Antaeus and (No. 2) Hercules slaying the monster Geryones. The remaining section of the barrel is blued and heavily encrusted with gold, chiselled with figures emblematic of fame and the martial virtues.

In view of the presence of the French royal arms on the escutcheon, the cypher of Louis XV inlaid in the stock, and his portrait on the lock, it would appear that these pistols were made for the personal use of Louis XV, King of France (1715–1774).

Jean Baptiste La Roche was *Arquebusier du Roi* and was granted *logement* in the Louvre in 1743; he died in 1769. The signature *Les La Roche* was used by J. B. La Roche in his later life when he was assisted by his son. Compare the pistol in the Wallace Collection (No. A.1216) believed to have been made for Louis, Dauphin of France.

An almost identical but slightly earlier pair by the same maker is preserved in the Palace of Capodimonte, Naples. These retain their original case, covered with red morocco and lined with blue silk. On the case is the monogram of Prince Ferdinand as used before his accession to the throne as King of the Two Sicilies in 1759. They were presumably a gift from Louis XV.

A flint-lock fowling piece in the Bayerisches National Museum, Munich (No. w.2890), decorated almost en suite with this pair of pistols and evidently by the same hand, is signed *Arault à Versailles*.

La Roche seems to have specialized in the production of highly-decorated guns, most of which were doubtless intended for presentation by the French King to foreign potentates.

Lit. T. Lenk, *Flintlåset*, pp. 113–15; several of La Roche's works are illustrated in Plates 92, 93.

Wallace Collection Catalogue, Arms and Armour, Part II (No. A.1216), gives a list of firearms signed by this maker.

91. PLATE XXXVIII. PAIR OF FLINT-LOCK PISTOLS. *Flemish (Liège); first quarter of eighteenth century.*

Purchased from the funds of the Farquharson Bequest. From the Palace of Gatschina near Leningrad. Length 19¾ in. M.184, 184a–1951

The barrels are signed *I. I. Behr*. The stocks of burr walnut, slightly carved, the mounts of bright steel, chiselled with figures of putti within panels enclosed by foliate scrolls against a gold-plated ground. On the thumb-plate and on the side-plate is chiselled a profile portrait of a man surmounted by a coronet of seven pearls.

The barrels of circular section with longitudinal sighting ribs have a silver foresight and are chiselled en suite with the mounts.

The locks are chiselled with foliage, figures of putti and masks against a gold plated ground.

Jean Jacob Behr is believed to have been active from about 1690 till the mid-eighteenth century. He is first recorded in Würzburg but seems subsequently to have gone to the Low Countries, where he is known to have worked in Maastricht and Liège. The form of this pair of pistols and, in particular, the design and execution of the chiselling suggest a Liège origin. A Liège pistol with ornament apparently chiselled by the same hand in the Musée d'Armes, Liège, is signed *Devilliers à Liège*.

92. PLATE XXXVIII. FLINT-LOCK PISTOL. *North Italian (Turin); second quarter of eighteenth century.*

Ramsbottom Bequest. Length 20½ in.

M.2817–1931

The stock of burr wood slightly carved to outline the mounts. The mounts of iron chiselled with foliage and gilt; the ramrod of iron damascened with gold is of Indian origin and has been added at a later date.

The lock-plate is chiselled with foliage and gilt en suite with the mounts. Underneath the cock, stamped in the lock-plate with single letter punches, the inscription *reggya.armerya. dy.toryno*.

The barrel, octagonal at the breech, the remainder round, is blued.

In the upper plane of the barrel are inset two stamps of copper, cased with gold foil. One bears the crowned arms of Savoy, the other a bull rampant, the device of the city of Turin.

This pistol was made in the Royal Armoury of the Kings of Sardinia at Turin. This armoury was probably mainly concerned with the production of military arms but evidently also made firearms for the personal use of the King. It was probably made during the reign of Victor Amadeus II, who abdicated in 1730.

Lit. J. F. Hayward: 'A flint-lock pistol from Turin'. *Bollettino Piemontese d'Archeologia e di Belle Arti*, 1949, p. 162.

93. PLATES XXXIX, XL. FLINT-LOCK FOWLING-PIECE. *English (London)*; 1749–50.
Length 53 in. 8–1883

The barrel signed *Wilson, London*, the mounts of silver bear the London hall-mark for 1749–1750 and the maker's mark of Jeremiah Ashley.

The walnut stock is inlaid with trophies of arms enclosed within fine rococo scrollwork executed in silver wire. The silver mounts are cast and chased with trophies of arms. The silversmith's mark is struck on the trigger-guard and on the butt-plate.

The lock is chiselled with panels containing trophies of arms against a matted gilt ground. It is signed *Wilson*.

The barrel of round section is decorated with a panel of chiselled ornament against a matted gilt ground at the breech, and with damascened scrollwork around the fore-sight. At the side of the breech, the London Gunmaker's proof and the maker's mark of R. Wilson.

Wilson seems to have produced a considerable number of richly-decorated arms, many of them, to judge from their ornament, intended for export to the Near East. He was one of the few London gunmakers who practised the technique of chiselling against a gilt ground.

94. PLATES XXXIII, XXXIX, XL.
AIR-GUN. *English (London); about* 1735–40.
From the collection of Alexander Davison, sold St. James' Square, 21 April, 1817, Lot 592.
Length 53½ in. 494–1894

The walnut stock finely carved with foliage and with rococo scrollwork, and inlaid with panels of chased or engraved silver. The remaining surface of the stock inlaid with silver wire scrollwork within which are inlaid naturalistic flowers, executed in cut and engraved silver. The silver panels inlaid in the stock represent, on the left-hand side, a figure of Minerva (or perhaps Britannia) surrounded by trophies of arms and of abundance, above her flies Mercury; on the right-hand side, a lion and an eagle, the latter symbolizing Jupiter. The panels on the forestock are engraved with cherubs and trophies of arms. In the butt-plate is a silver trap which, when opened, gives access to the pump. This operates in a cylindrical cavity bored through the butt. The mounts of silver are finely chased; the side-plate is pierced and chased with a seated figure of a winged divinity with two cherubs symbolic of the winds surrounded by military trophies.

The trigger-guard is chased with a recumbent lion under a baldachin supported by a male and a female term, and, on the loop, with a figure of Minerva (or Britannia) accompanied by trophies of arms within rococo scrolls, the thumb-plate with a putti and military trophies, the butt-plate with a scene of citizens handing over the keys of a city, in the background, combating warriors. The two upper ramrod pipes are later and inferior restorations. The lock is chiselled against a granulated gilt ground, the cock with Jupiter brandishing the Fulmen, the plate with scrollwork and military trophies. It is signed *Kolbe*. The lock is of normal flint-lock construction; when the scear is released, the tumbler turns and forces down a lever which in turn opens the valve of the compressed air cylinder.

The barrel of brass is covered at the breech by a sleeve of silver; this is chased with a figure of Mars amongst trophies of arms. The barrel is signed *Kolbe Fecit Londini*. The actual barrel is contained within a brass cylinder which serves as the compressed air container. There is a back-sight and a fore-sight, the latter formed as a grotesque mask.

When sold in 1817, this gun was described as having been 'formerly in the possession of

61

George II'. Though it is not possible to prove this assertion, the piece is of such splendid quality that it must have been made for some very influential personage. If it was made for the King, it is surprising that the escutcheon should have been left blank.

Johann Gottfried Kolb (or Kolbe) was an iron-chiseller and engraver of Suhl in Thuringia. According to Støckel, Kolb was active in Suhl from about 1735 to 1753, but the gunmakers' company minutes show that he was in London from 1730-7. An air-gun of similar construction signed by him is in the Keith Neal Collection, Warminster, and there is a pair of five-barrelled pistols signed *Kolbe Invt London* in the Windsor Armoury (Nos. 798, 807). His most imposing work is the set of two rifles, two fowling pieces and a brace of pistols, made for Charles III of Spain, and now in the Palace of Capodimonte, Naples.

95. PLATE XXXIX. FLINT-LOCK FOWLING PIECE. *French (Paris); dated 1777-8.*

From the Bernal Collection, Lot 2219. Length 55 in. 2195-1855

The walnut stock of half length is slightly carved, the mounts of silver, chased with hunting subjects and with trophies. On the buttplate, the Paris hall-mark for 1777-8. The comb of the butt is provided with a green velvet cheek-piece.

The lock-plate, chiselled and gilt with a reclining huntsman with hound, is signed *Delety à Paris Rue Coquillière*.

The barrel, octagonal at the breech, is of round section towards the muzzle and is provided with a sighting rib along the top. The barrel is blued and gilt, the section towards the breech is incised with foliage and trophies. It bears the stamp of A. P. Esteva of Barcelona (Støckel No. 328).

This gun was constructed for firing from the left shoulder; the lock is placed on the left-hand side of the stock. Støckel records two masters of this name, presumably father and son, working in the rue Coquillière, Paris.

96. PLATE XLI. MIQUELET-LOCK PISTOL, the lock stamped with the mark of Miguel Ybarzabal of Eibar. *Spanish; late eighteenth century.*

Given by A. S. Reade. Length 13¾ in.
 M.104-1920

Walnut stock, slightly carved, chiselled steel mounts enriched with gilding. The butt of hooked form with pommel extending up back as far as the barrel tang.

Miquelet lock, the rear end chiselled with flowers against a gilt ground. Stamp of Miguel Ybarzabal covered with gold foil. The steel filed with five grooves.

Blued barrel of Spanish form, octagonal at breech and round at muzzle, the point of juncture chiselled with a wreath of acanthus leaves against a gold ground. The breech stamped with the maker's mark with a fleur de lys on each side. The upper facets over the chamber inlaid with silver foliate scrolls. The barrel secured by pins instead of the bands more usual on Spanish arms.

97. PLATE XLI. FLINT-LOCK. *Spanish (Madrid); mid-eighteenth century.*

Joicey Bequest. Length 6 in. M.278-1919

Signed with a stamp covered with gold foil G(abriel) *el algora*, who was appointed gunmaker to King Ferdinand VI of Spain in 1749 and died in 1761. The surface is chiselled with ornament against a matt gold ground, including hunting scenes and Venus mourning the dead Adonis.

This type of lock, the profile of which corresponds to that of the French flint-lock, was adopted in Spain during the eighteenth century under the French influence introduced by the Spanish Bourbons.

Lit. J. Lavin: *Spanish Firearms,* p. 254.

98. PLATE XLII. FLINT-LOCK FOWLING PIECE signed by D. Egg, London: silver mounts with London hall-mark for 1801.

Length 61 in. M.5-1956

The barrel blued and inlaid at the breech in gold letters with the maker's signature *D. Egg.*, at the muzzle with a dragon's head also in gold. Originally fully stocked, the gun is now half-stocked and two silver pipes are soldered to the

under-side of the barrel. The walnut stock is profusely inlaid with trophies of Turkish arms and with rosettes and scrolls in silver wire. The back-sight is of saddle-shape and is attached to a band sliding over the barrel and stock; it was probably added abroad, perhaps in France. The remaining silver mounts bear the maker's mark of the London small-worker, *Moses Brent*.

The lock is of normal construction but is equipped with a safety-catch that locks both cock and pan-cover. It is inlaid with scroll-work and signed *D. Egg* in gold. It retains its original fire-blue finish.

The barrel tang is inlaid with a trophy of arms in gold incorporating two shields, engraved with the English and French royal arms. These are probably decorative only.

The orientalizing style of the decoration suggests that this gun was intended for presentation to some eastern prince, but it was acquired in France. A pair of presentation pistols by Wilson at Warwick Castle have similar orientalizing mounts by Moses Brent. The thumb-plate is cast from the same mould.

99. PLATE XLII. DOUBLE-BARRELLED FLINT-LOCK FOWLING PIECE, the locks signed *Aubrun à Nantes. French; early nineteenth century.*

Length 44¼ in. M.24–1958

The barrels are blued, engraved with foliage and gilded over the chamber and around the foresight. They are brazed to a central strip and are stamped underneath with a version of the St. Etienne mark, consisting of crossed palms surmounted by the letter A. Gold lined vents, false breech.

Walnut half-stock carved with foliage and flowers around the fore-end and the tang of the barrel. A lion's mask is carved at the bottom of the grip. Felt cheek pad covered with velvet (restored), silver mounts engraved with foliage and animals. The trigger-guard and fore-end are cast and chased with lion's masks in relief. In front of the trigger-guard an oval silver escutcheon engraved with the crest of Thellusson, probably for John Thellusson, second Baron Rendlesham (1785–1832). The locks are blued and engraved and have been

fitted in England with gravitating stops, a device patented by Joseph Manton in June 1812.

Aubron is not recorded as a gunmaker and it is probable that he was merely the retailer of a gun made at Saint Etienne.

100. PLATE XLIII. PAIR OF DOUBLE-BARRELLED FLINT-LOCK POCKET PISTOLS. *English; dated 1823–4.*

Ramsbottom Bequest. Length 6⅛ in.

M.2802a–1931

Walnut stocks with chequered grips, the engraved silver mounts bear the London hall-mark for 1823–4. Octagonal blued barrels arranged one over the other, the signature *J. Egg London* inlaid in gold lettering. Pommel caps of gold, engraved with a cypher (owner's initials). The locks are fitted with external mainsprings linked to the toe of the cock and are signed *Josh. Egg.*

With their waterproof pans and spurred cocks, these pistols represent the last development of the flint-lock in England. The mainspring acts on both the cock and the steel. The single trigger discharges the two barrels consecutively.

Joseph Egg, nephew of the famous maker of duelling pistols, Durs Egg, was in business at No. 1, Piccadilly when these pistols were made.

101. PLATE XLIII. PAIR OF FLINT-LOCK PISTOLS signed *Boutet à Versailles. French; about 1820.*

Purchased from the funds of the Farquharson Bequest. Length 15 in. M.38, 38a–1960

Stub twist barrels with hair-rifling hooked into false breeches. The barrels are stained grey and inlaid in gold with the maker's signature, an arrow and the number 93. Gold touch-holes, rear and fore-sights of gold. Numbered 1 and 2 respectively on the false breeches. The locks have water-proof gold-lined pans and are engraved with scenes of buildings and signed *Boutet à Versailles.* Walnut half stocks, chequered butts terminating in a flat ebony butt-cap with a border of carved acanthus enclosing an oval steel plaque chiselled with honeysuckle ornament. Engraved steel furniture, oval gold escutcheon plate.

M. Bottet in *Le Manufacture d'Armes de Versailles*, Paris, 1903, p. 51, suggests that the numbers on the barrels were Boutet's private serial numbers. He states that firearms of this kind which bear the signature 'Boutet à Versailles' inlaid in gold in very large cursive lettering were made after 1813, but they are probably later still. When in 1818 Boutet left Versailles on the expiration of the eighteen year concession he had obtained, he moved to Paris and set up at No. 87 Rue de Richelieu, Paris. He continued, however, to use the signature 'à Versailles' to which he was no longer really entitled.

THE PLATES

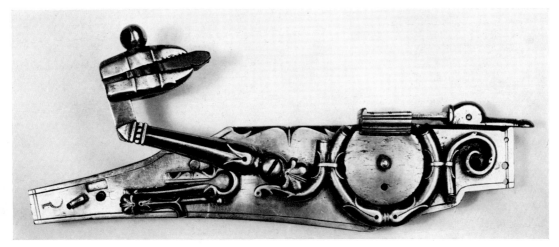

1

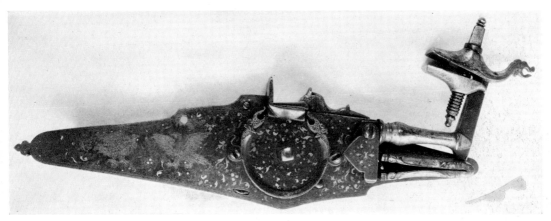

2

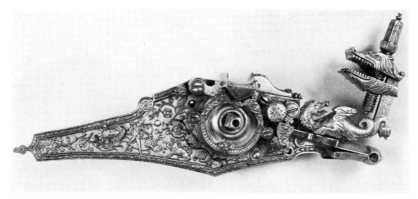

3

PLATE I. 1. Wheel-lock with self-spanning gear. South German, 1540–50. 2. Wheel-lock for a gun. German, *c.* 1600. 3. Wheel-lock for a pistol. South German, 1620–30.

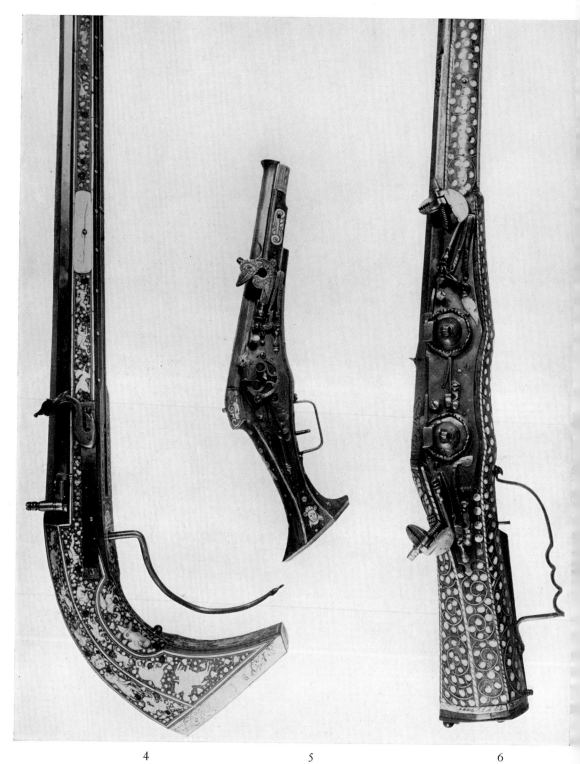

PLATE II. 4. Match-lock petronel. French, second half sixteenth century. 5. Wheel-lock pistol. South German, last quarter sixteenth century. 6. Wheel-lock gun. German, 1581.

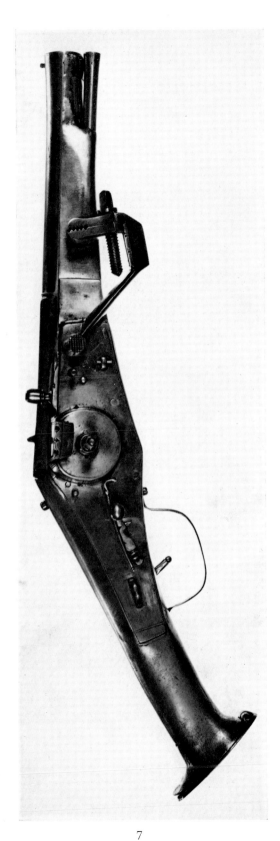

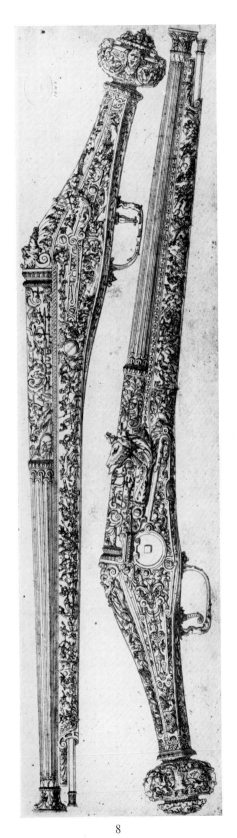

7 8

PLATE III. 7. Wheel-lock pistol. German, 1579. 8. Design for wheel-lock pistols. South
German, late sixteenth century

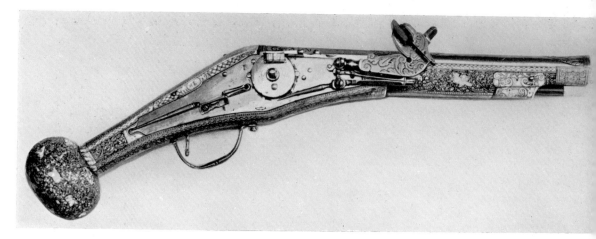

9

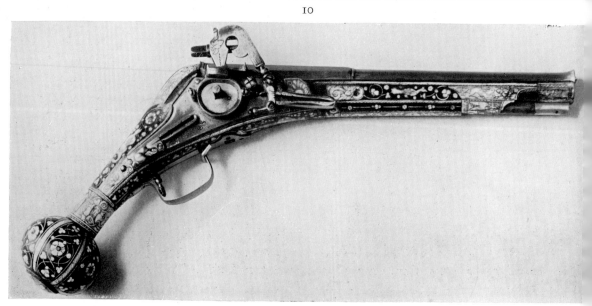

10

11

PLATE IV. South German wheel-lock pistols. 9. 1579. 10. Last quarter sixteenth century. 11. 1593.

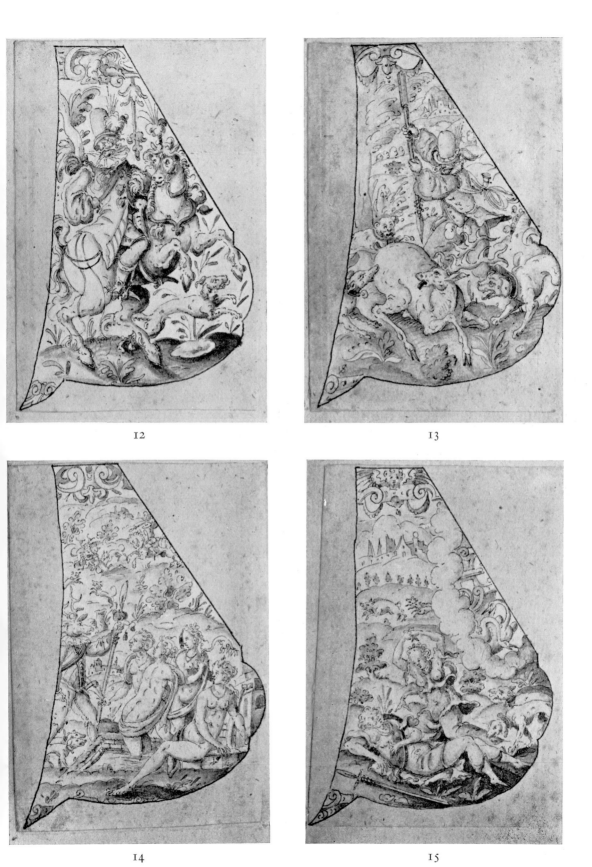

12

13

14

15

PLATE V. 12–15. Designs for engraved ornament on butt-plates. German, late sixteenth century.

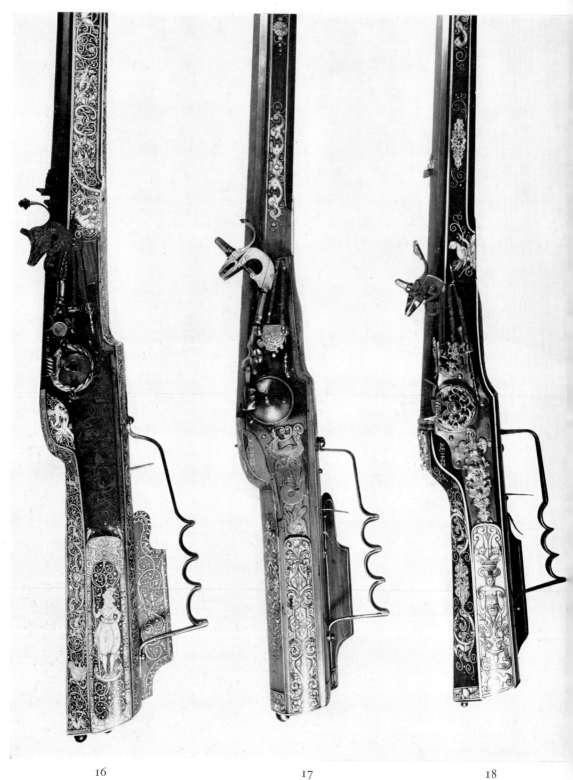

16

PLATE VI. Wheel-lock rifles. 16. East German, early seventeenth century. 17. German, 160
18. Saxon, 1606.

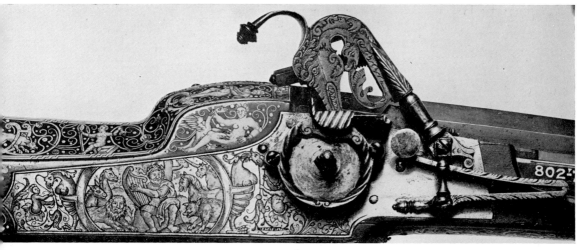

16

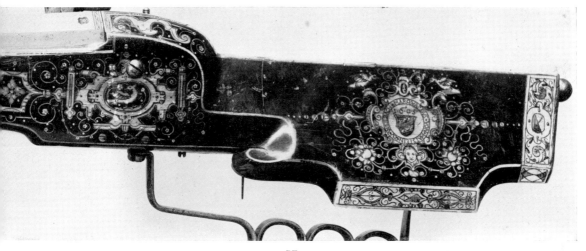

17

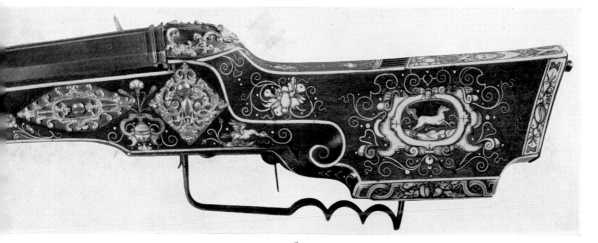

18

PLATE VII. Details of rifles on PLATE VI.

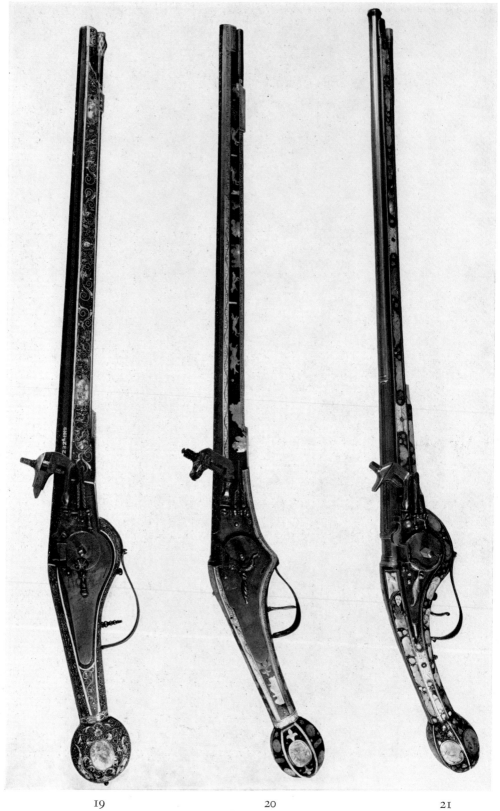

PLATE VIII. Wheel-lock pistols. 19. German, *c.* 1600–10. 20. South German, first quarter
seventeenth century. 21. French, *c.* 1610–20.

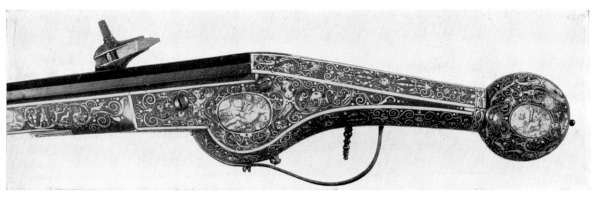

19

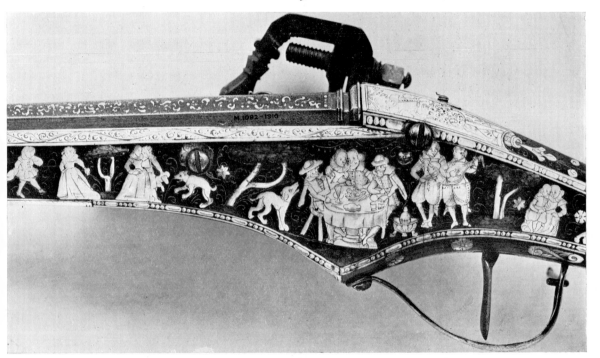

20

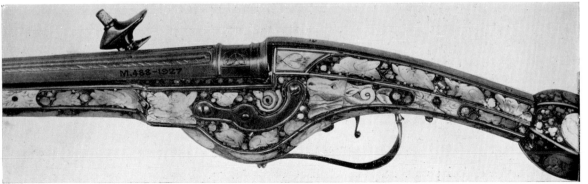

21

PLATE IX. Details of pistols on PLATE VIII.

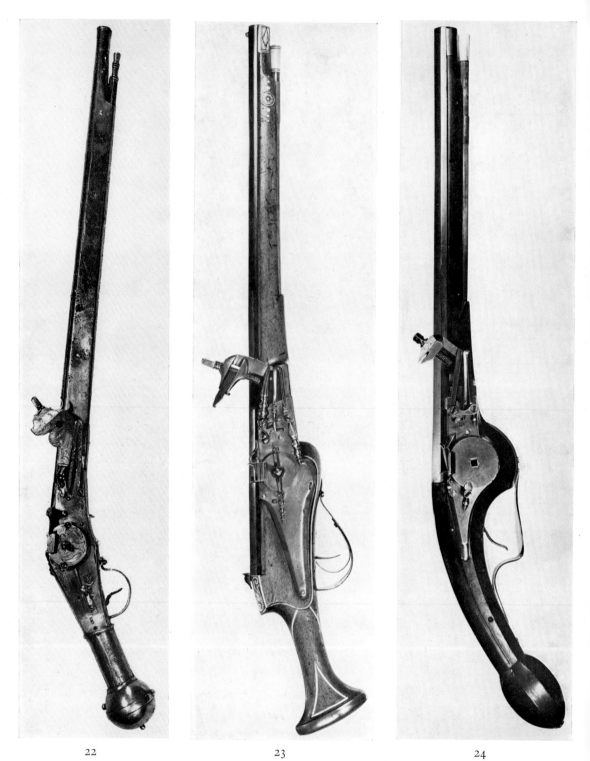

22　　　　　　　　　　23　　　　　　　　　　24

PLATE X. Wheel-lock pistols. 22. South German, *c.* 1570–80. 23. German, early seventeenth century
24. French, second quarter seventeenth century.

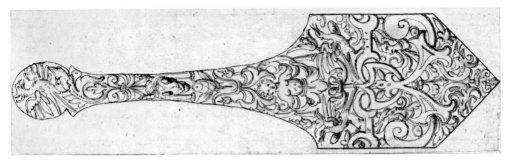

25

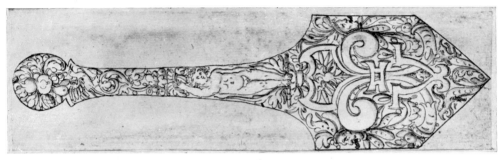

26

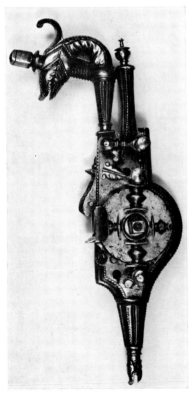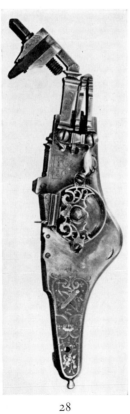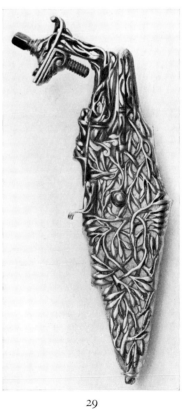

27

28

29

PLATE XI. 25–26. Designs for engraved ornament on butt-plates. German, end of sixteenth century. 27–29. Wheel-locks. 27. French, late sixteenth century. 28. French, *c.* 1600–25. 29. North Italian, *c.* 1650.

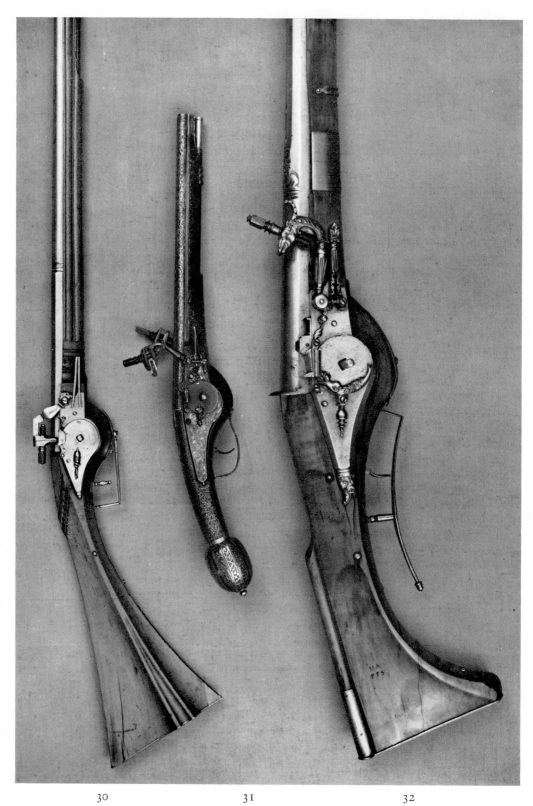

PLATE XII. 30. Wheel-lock gun. French, *c.* 1600. 31. Wheel-lock pistol. French, *c.* 1600.
32. Wheel-lock fowling piece. French, *c.* 1620–30.

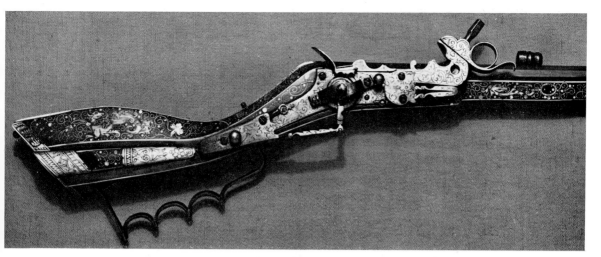

33

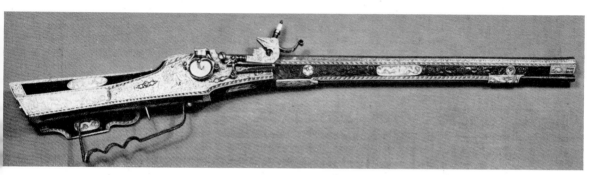

34

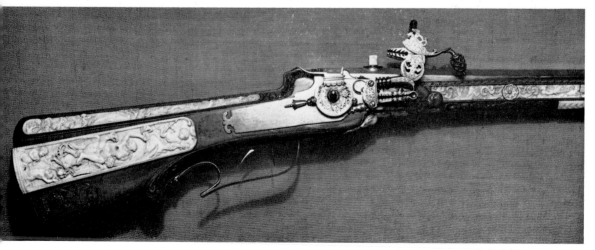

35

PLATE XIII. 33. Tschinke. Silesian, *c.* 1650. 34. Wheel-lock rifle. South German, *c.* 1600. 35. Wheel-lock rifle. South German, *c.* 1670–80.

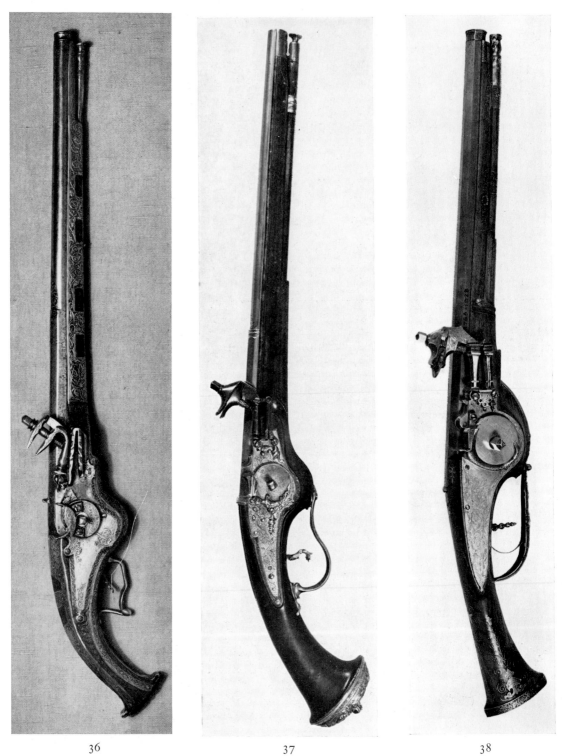

36 37 38

PLATE XIV. 36–38. Wheel-lock pistols. 36. Spanish, 1614. 37. Swiss, second quarter seventeenth
century. 38. German, c. 1620–30.

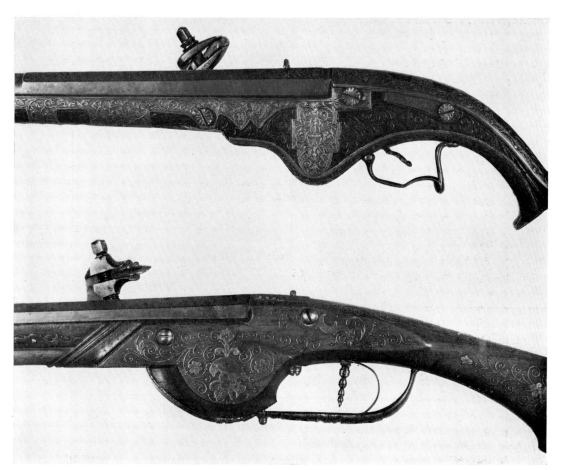

36 and 38

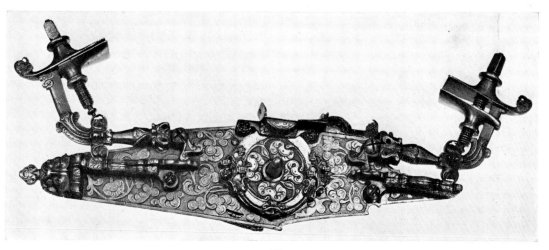

39

PLATE XV. Details of pistols on PLATE XIV, 36 and 38. 39. Wheel-lock with twin cocks. Italian, *c.* 1650.

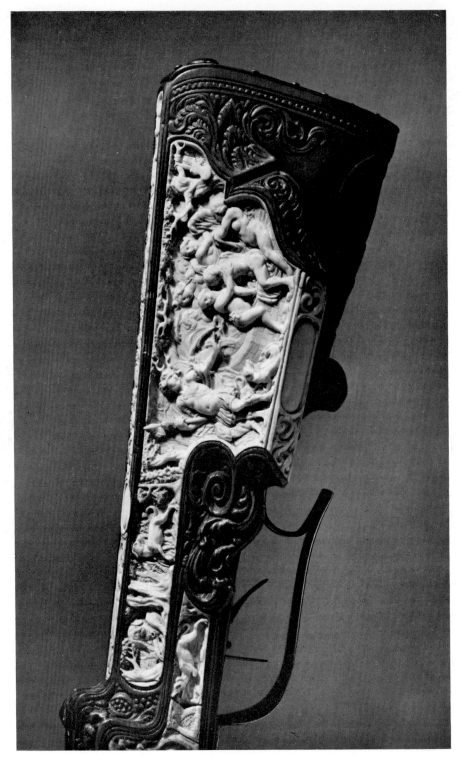

35

PLATE XVI. Detail of rifle on PLATE XIII, 35.

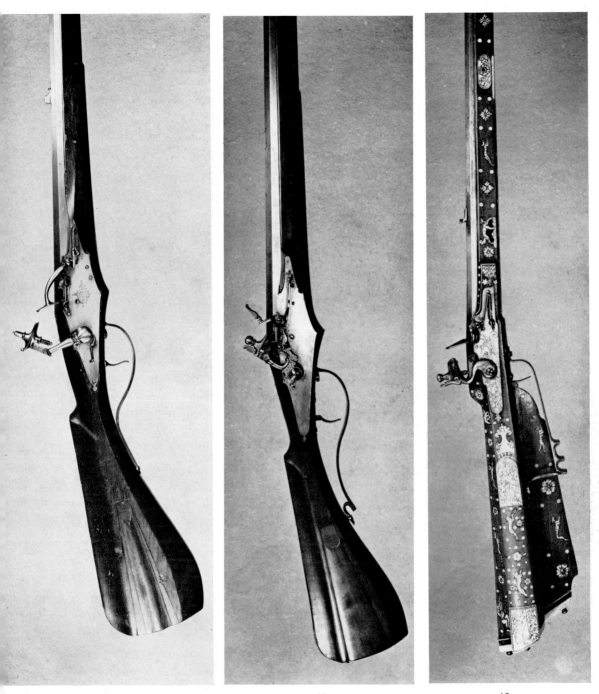

40 41 42

PLATE XVII. 40–41. French guns. 40. *c.* 1620–30, with Italian snaphaunce lock. 41. *c.* 1625–50.
42. Flint-lock rifle. Russian, *c.* 1650.

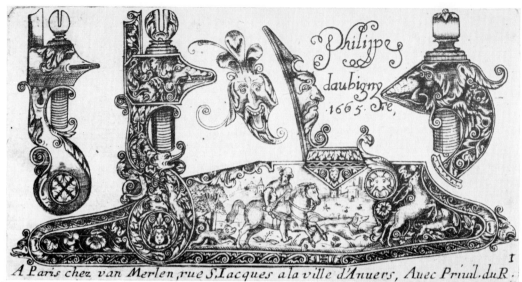

43

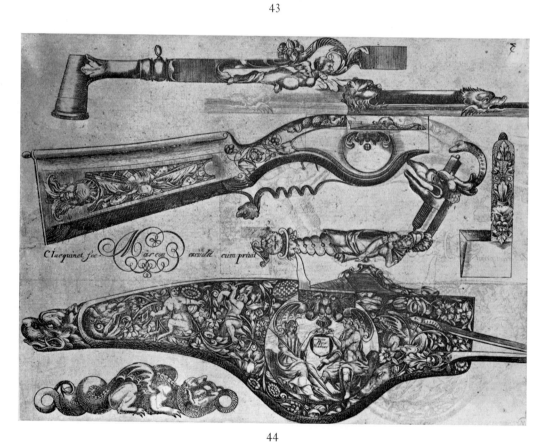

44

PLATE XVIII. 43. Plate from a pattern book. French, 1635. 44. Designs for ornament on wheel-lock firearms. French, 1657.

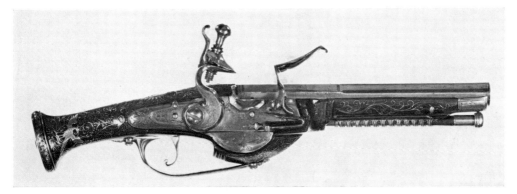

45

46

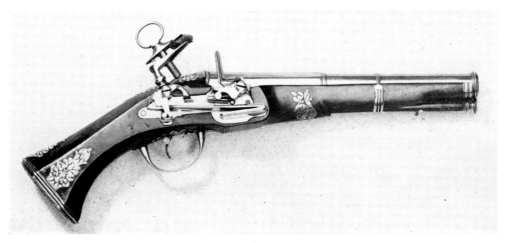

47

PLATE XIX. 45. Flint-lock pistol. German, stock *c.* 1650; lock early eighteenth century.
46. Miquelet lock. Italian, *c.* 1650. 47. Miquelet lock pistol. Spanish, *c.* 1650–75.

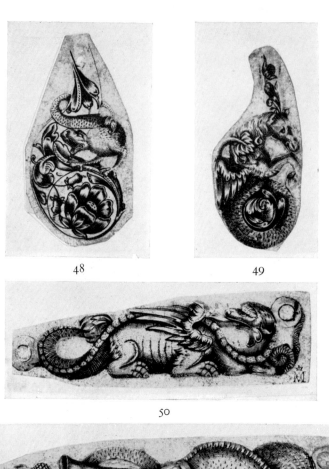

48

49

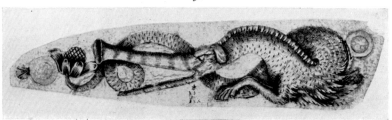

50

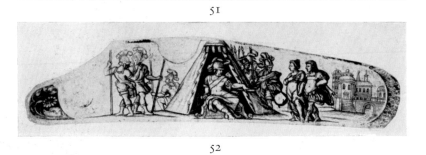

51

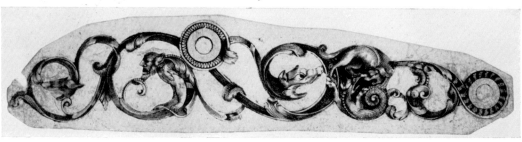

52

53

PLATE XX. 48–53. Prints from engraved ornament on French mid-seventeenth century firearms.

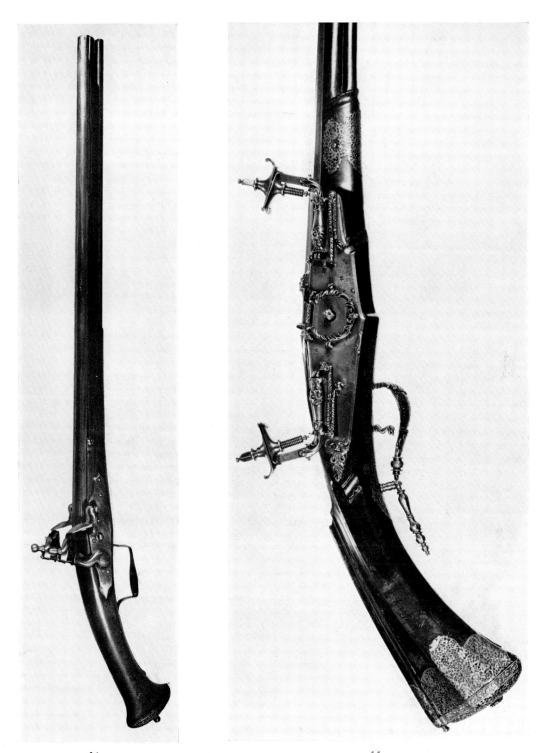

54 55

PLATE XXI. 54. Flint-lock pistol. French, *c.* 1630–40. 55. Wheel-lock gun. Italian, *c.* 1625–50.

56

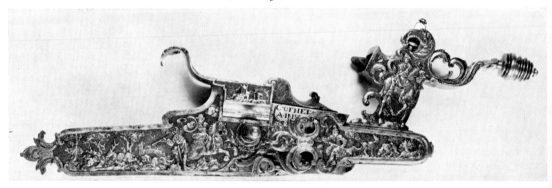

57

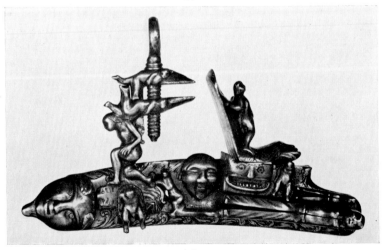

58

PLATE XXII. 56. Designs for ornament on flint-lock firearms. French, c. 1660. 57. Wheel-lock. Austrian, first half eighteenth century. 58. Miquelet lock. Italian, eighteenth century.

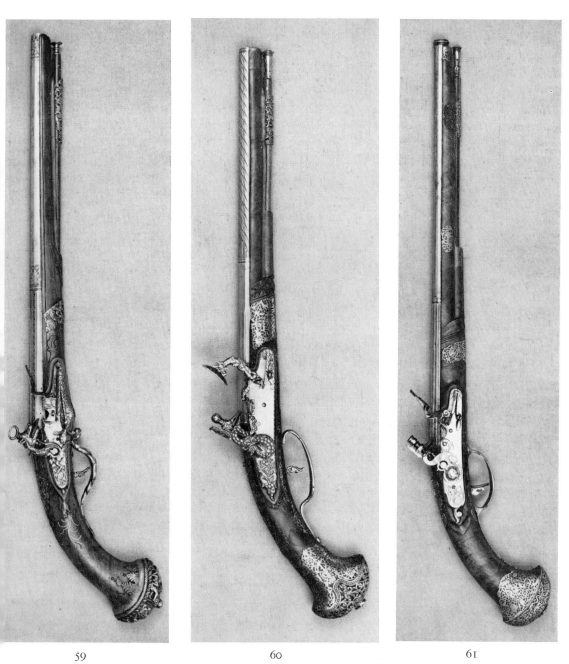

<div align="center">

59 60 61

</div>

PLATE XXIII. 59. Flint-lock pistol. Italian, *c.* 1650. 60. Snaphaunce pistol. North Italian, *c.* 1650.
61. Flint-lock pistol. North Italian, third quarter seventeenth century.

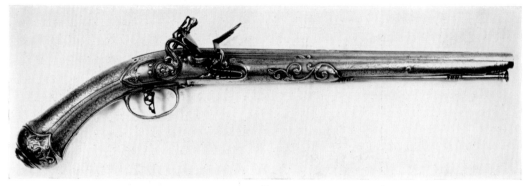

62

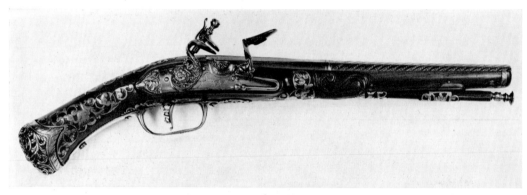

63

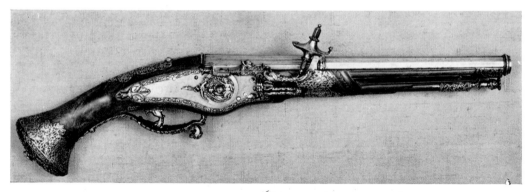

64

PLATE XXIV. North Italian pistols. 62. Flint-lock. Last quarter seventeenth century. 63. Flint-lock, *c.* 1670–80. 64. Wheel-lock, *c.* 1650.

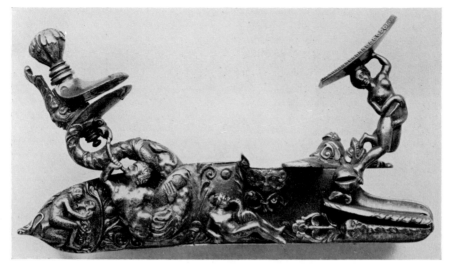

65

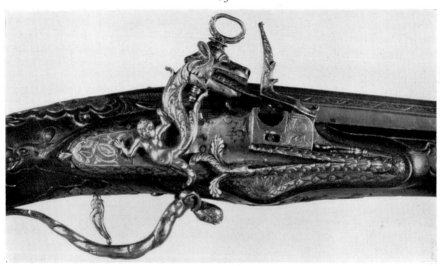

59

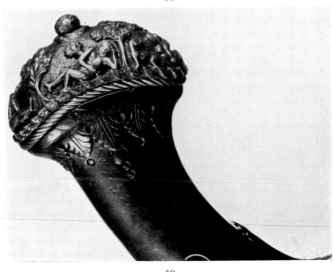

59

PLATE XXV. Details of pistol on PLATE XXIII, 59. 65. Snaphaunce lock. North Italian, third quarter seventeenth century.

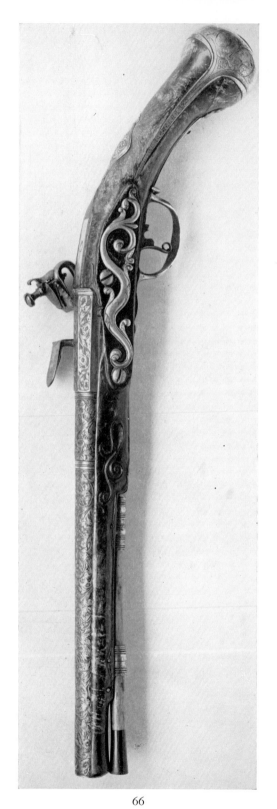

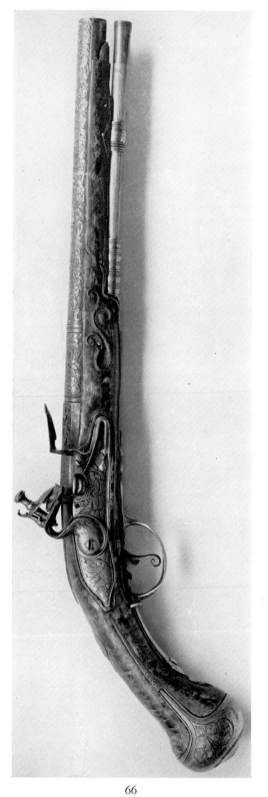

66

66

PLATE XXVI. 66. Pair of flint-lock holster pistols. English? 1660–80.

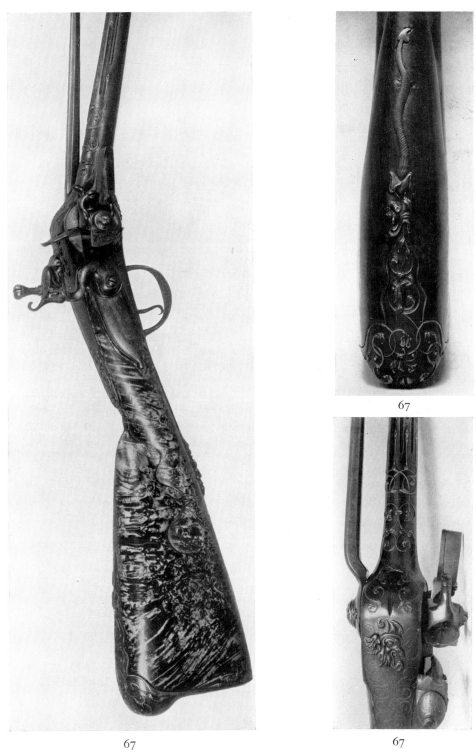

67

67

67

PLATE XXVII. 67. Flint-lock breech loading magazine gun. English, *c.* 1680.

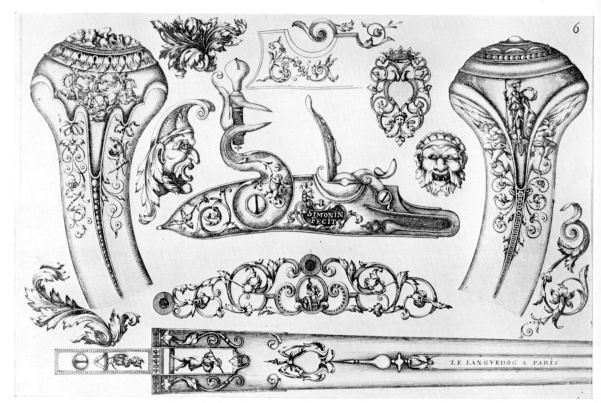

68

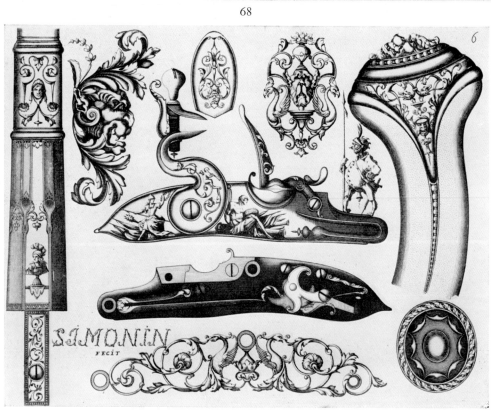

69

PLATE XXVIII. French designs for ornament on flint-lock pistols. 68. 1685. 69. 1693.

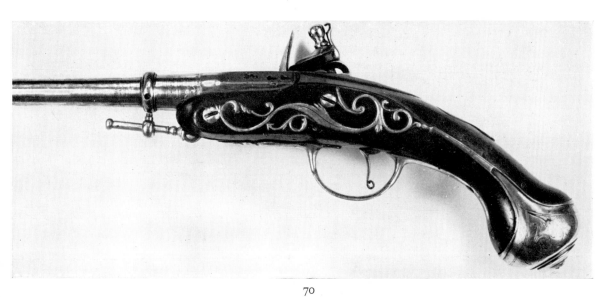

70

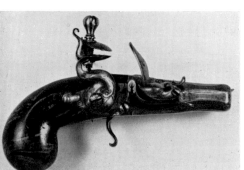

71

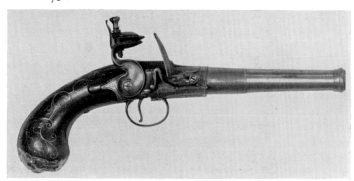
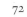

72

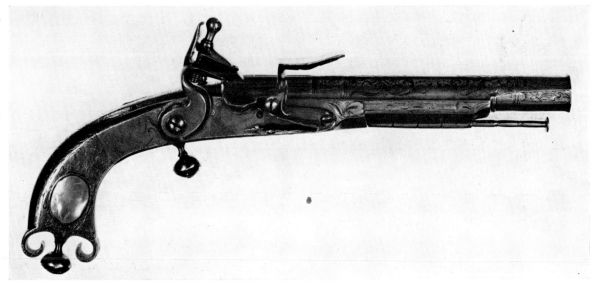

73

PLATE XXIX. Flint-lock pistols. 70. English, late seventeenth century. 71. English, *c.* 1680. 72. English, *c.* 1725–30. 73. Scottish, *c.* 1750.

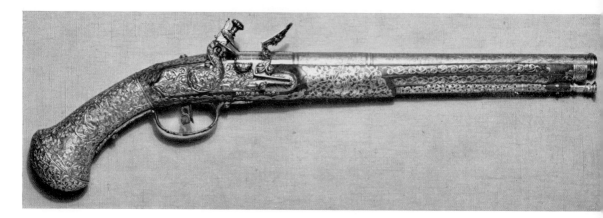

74

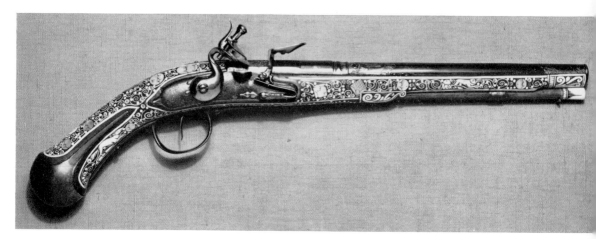

75

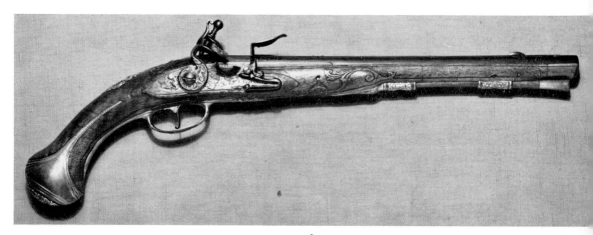

76

PLATE XXX. Flint-lock pistols. 74. North Italian, *c.* 1690. 75. Silesian, *c.* 1680. 76. Bohemian
c. 1720–30.

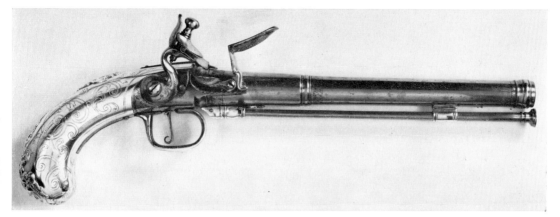

77

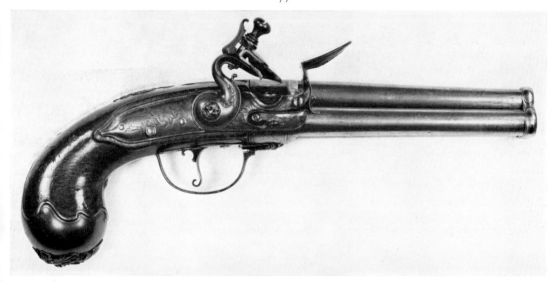

78

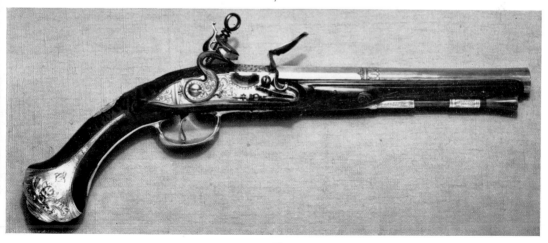

79

PLATE XXXI. Flint-lock pistols. 77. Flemish, *c.* 1720–30. 78. Italian, *c.* 1680. 79. Spanish, *c.* 1750.

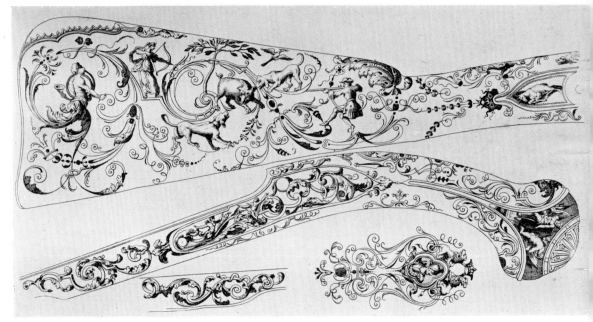

80

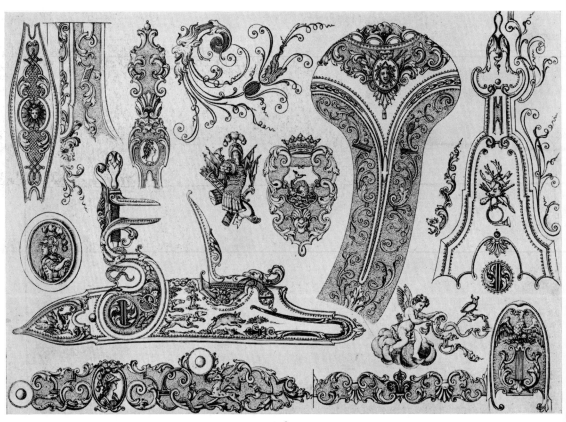

81

PLATE XXXII. French designs for ornament on flint-lock firearms. 80. *c.* 1700. 81. 1730.

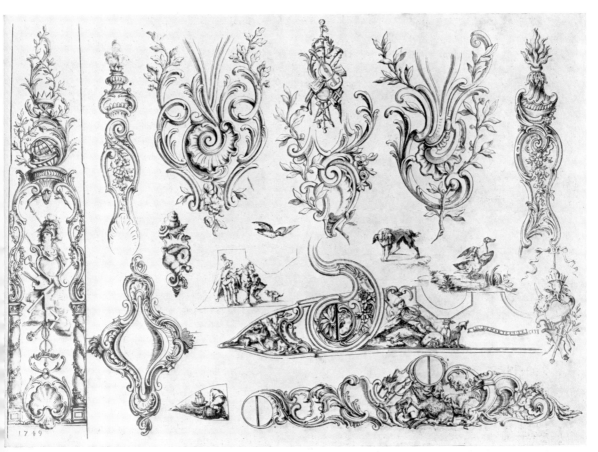

82

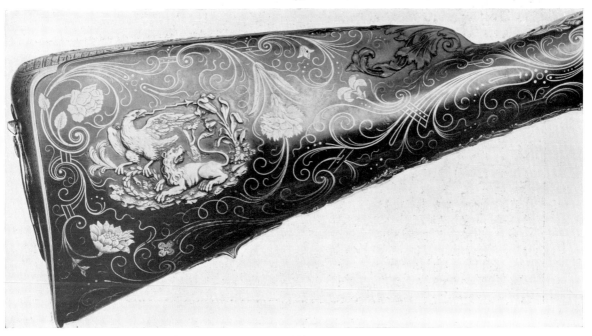

94

PLATE XXXIII. 82. Designs for ornament on flint-lock firearms. French, 1749. Detail of air-gun on
PLATE XXXIX, 94.

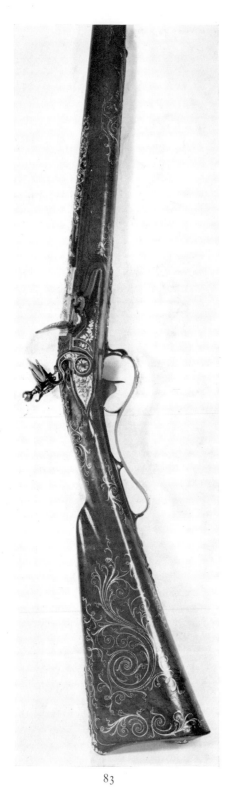

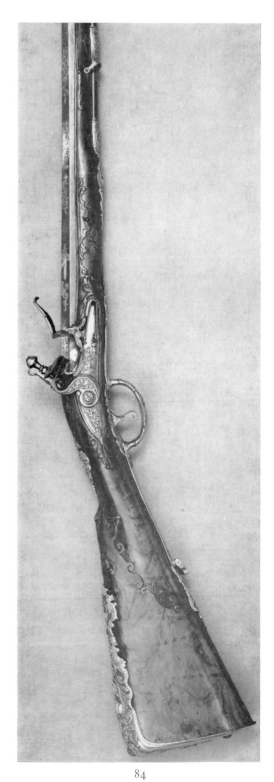

83

84

PLATE XXXIV. Flint-lock fowling pieces, 83. Russian, *c.* 1778. 84. Italian, second quarter eighteenth century.

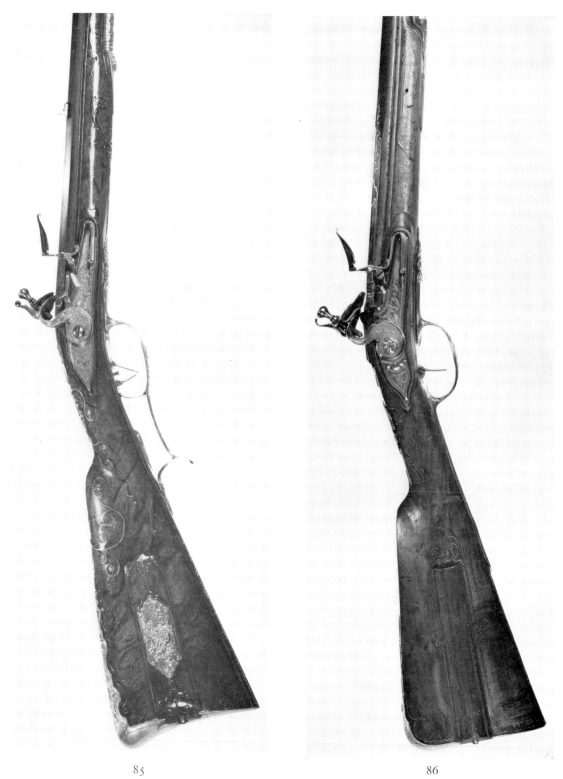

85 86

PLATE XXXV. 85. Flint-lock rifle. Bohemian, first half eighteenth century. 86. Flint-lock fowling
piece. Russian, first half eighteenth century.

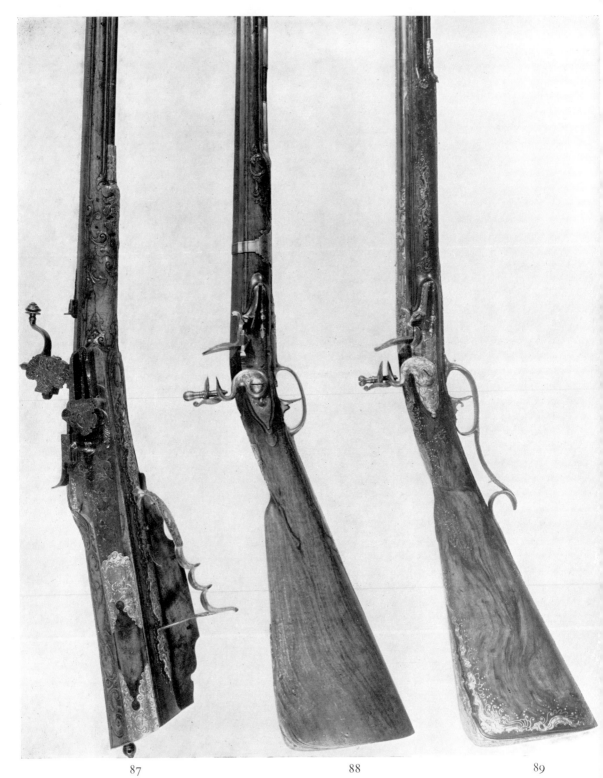

87 88 89

PLATE XXXVI. 87. Wheel-lock rifle. South German, *c.* 1700. 88–89. German flint-lock fowling pieces.
88. 1724. 89. 1750.

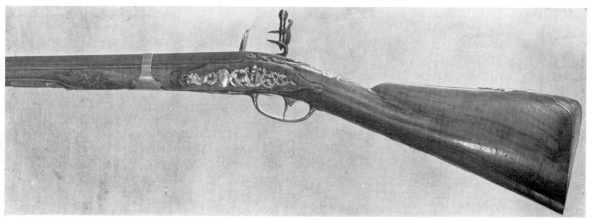

88

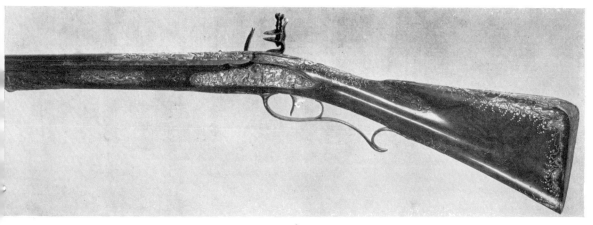

89

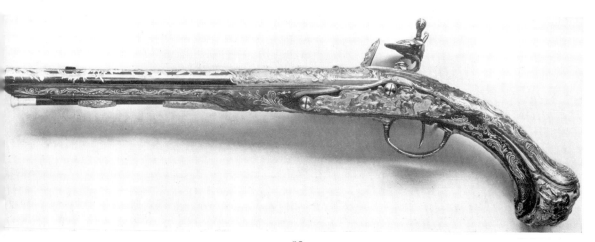

90

PLATE XXXVII. Details of fowling pieces on PLATE XXXVI, 88 and 89. 90. Flint-lock pistol. French, c. 1750–60.

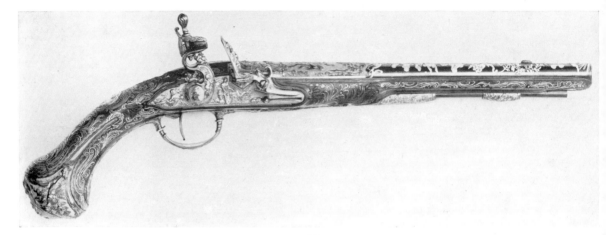

90

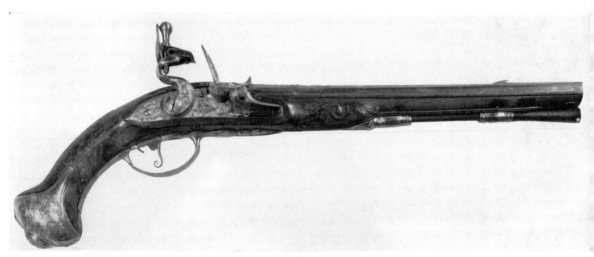

91

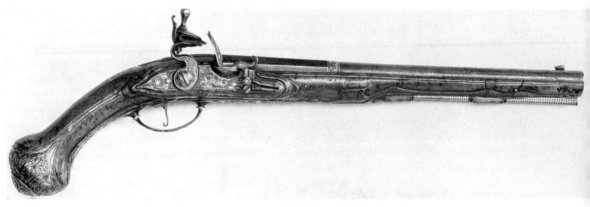

92

PLATE XXXVIII. Detail of pistol on PLATE XXXVII, 90. 91–92. Flint-lock pistols. 91. Flemish, first quarter eighteenth century. 92. North Italian, second quarter eighteenth century.

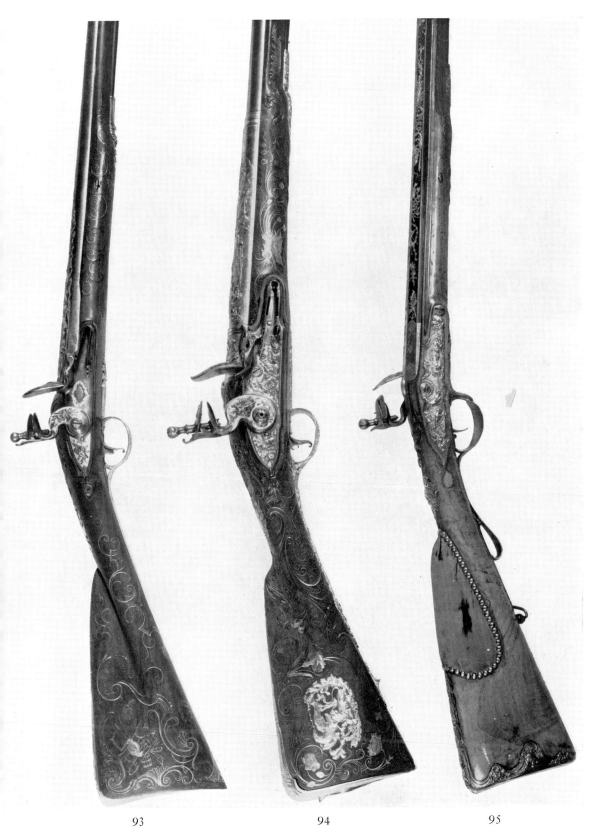

93 94 95

PLATE XXXIX. 93. Flint-lock fowling piece. English, 1749–50. 94. Air-gun. English, *c.* 1735–40.
95. Flint-lock fowling piece. French, 1777–78.

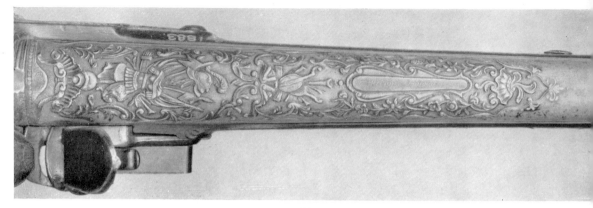

93

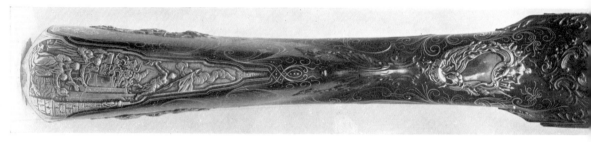

94

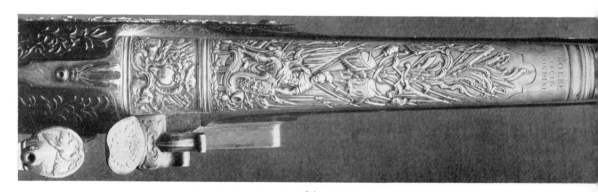

94

PLATE XL. Details of firearms on PLATE XXXIX, 93 and 94.

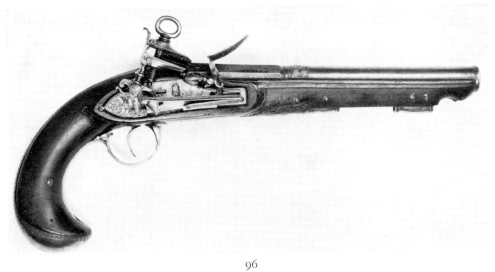

96

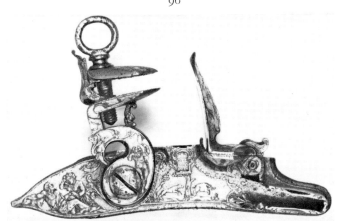

97

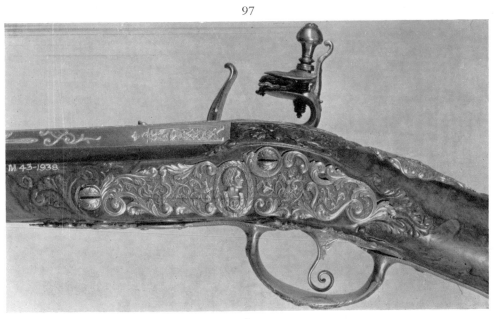

84

PLATE XLI. Detail of fowling piece on PLATE XXXIV, 84. 96. Miquelet-lock pistol. Spanish, late eighteenth century. 97. Madrid-lock. Spanish, *c.* 1750.

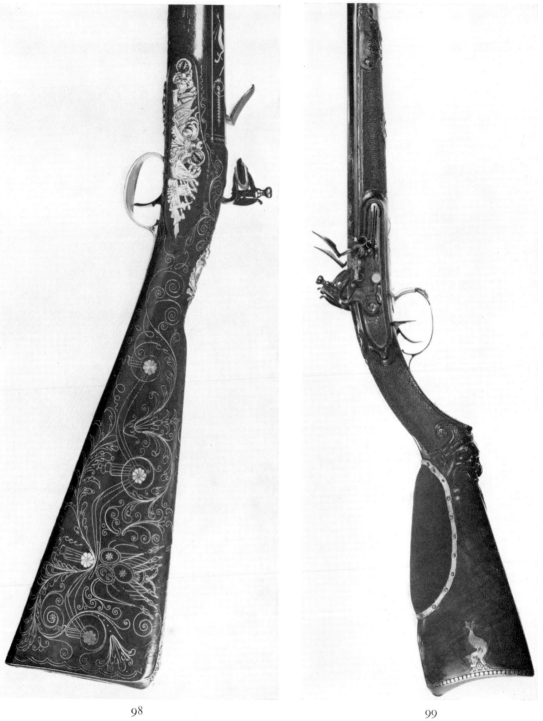

98 99

PLATE XLII. 98. Flint-lock fowling piece. English, early nineteenth century. 99. Flint-lock fowling piece. French, early nineteenth century.

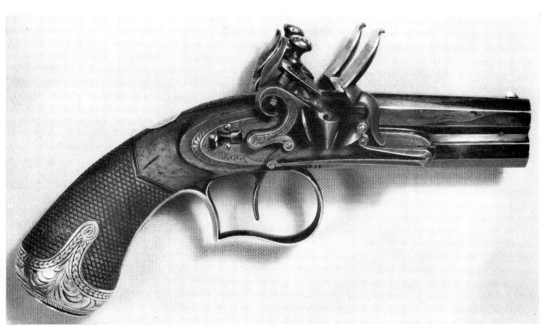

100

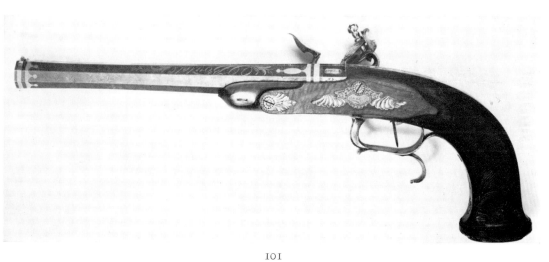

101

PLATE XLIII. Flint-lock pistols. 100. English, 1823–24. 101. French, *c.* 1820.

DATE DUE